An American Painter Abroad:

Frank Duveneck's European Years

Cincinnati Art Museum

An American Painter Abroad:
Frank Duveneck's European Years

by Michael Quick

Cover illustration:
Plate 27. *Study of Three Heads with Salver and Jar,*
ca. 1883, oil on canvas, 33½ x 44⅞ inches.
Cincinnati Art Museum, 1915.77.

An American Painter Abroad: Frank Duveneck's European Years
Exhibition dates: October 3, 1987-January 3, 1988

Cataloging Notes:

Quick, Michael.

 An American painter abroad : Frank Duveneck's European years.

 Catalog published on the occasion of the
Centennial of the Art Academy of Cincinnati, 1987.
 Bibliography: p.
 Includes index.

1. Duveneck, Frank, 1848-1919 – Catalogs. I. Cincinnati Art Museum (Ohio).
II. Art Academy of Cincinnati (Ohio). III. Title.

ND 237 D8Qu4 1987 87-71528
ISBN 0-931537-07-X

Contents

This exhibition and catalogue are dedicated
to the Art Academy of Cincinnati
in recognition of its Centennial celebration in 1987.

Foreword

It is well known that the Cincinnati Art Museum possesses the largest collection of paintings by Frank Duveneck, one of America's premiere painters of the last quarter of the nineteenth century and a renowned teacher. This is entirely fitting, as Duveneck's life and career centered in Cincinnati. Toward the end of his life, as he concentrated on teaching at the Art Academy of Cincinnati, where he was also Dean, he collected assiduously his own works. The intended home for this collection, spanning practically the entire period from student days in Munich to the instructional period in Cincinnati and Gloucester, was the Cincinnati Art Museum.

The designation of the Cincinnati Art Museum as the repository of his paintings may have occurred to Duveneck as early as 1904 when he donated his masterpiece, *Whistling Boy*, (accession no. 1904.196). At this same time, Duveneck presented another example from his Munich period, *Woman with Forget-Me-Nots* (accession no. 1904.195). These were not the first works by Duveneck to enter the Museum, however, for the institution's first director, Alfred Traber Goshorn (1833- 1902), conveyed his portrait (accession no. 1898.220) in 1898, only one year after it was painted. In 1907, a portrait of the noted Cincinnati woodcarver and teacher, Henry L. Fry (1807-1895), was presented (accession no. 1907 .193), and in 1914 the Cincinnati Art Museum made its first purchase of a Duveneck painting, *Head of a Girl* (accession no. 1914.16), utilizing the Kate Banning Fund.

But the core of the Museum's Duveneck holdings was assured when Joseph H. Gest, director of the Museum, reported to the Board of Trustees of the Cincinnati Museum Association at its meeting on May 18, 1915, that Frank Duveneck wished to present a "gift which comprises all of Mr. Duveneck's work with the exceptions only of the comparatively small number of canvases which he disposed of many years ago." Furthermore, Mr. Gest "commented on the fact that it is almost unique in that few artists of his rank retain possession of their work to that extent and few indeed are in a position to dispose of it by gift." The trustees obviously were delighted, and they expressed this pleasure in the *Minutes*: " . . . the influence of the most notable painter to arise here, one whose work and personality have impressed themselves upon the current of modern American art in a manner not to be overestimated and whose reputation has long been world-wide both as a painter and as a teacher." Since 1915, the Cincinnati Art Museum's representation of Duveneck through paintings, prints, and drawings is second to none, with portraits, landscapes, mural concepts, oil sketches, and instructional exercises on canvas rising to 115 accessioned works.

The Museum's Duveneck collection is among very few such rich and extensive treasuries representing a major artist's career. Because of Duveneck's role in American art, his leadership of the Cincinnati school, and the large holdings of the Cincinnati Art Museum, a gallery devoted exclusively to Frank Duveneck is maintained. Thanks to a generous endowment provided by Mr. and Mrs. A. M. Kinney, Jr., paintings are shown in the Duveneck gallery on a rotating basis and conservation is subsidized. Since 1979 when we published the catalogue of

paintings by Cincinnati artists in the Cincinnati Art Museum collection (*The Golden Age: Cincinnati Painters of the Nineteenth Century Represented in the Cincinnati Art Museum*) and exhibited selections by these regional artists, we have intended to stage an exhibition focusing on Duveneck's most fruitful years. This is now accomplished in the present exhibition and its accompanying catalogue by guest curator, Michael Quick, Curator of American Art at the Los Angeles County Museum of Art.

The Cincinnati Art Museum is grateful to Michael Quick for his perceptive appraisal in this catalogue and for his selection of paintings for this exhibition. It is the most important exhibition devoted to Duveneck since the exhibition of 1936, when the Museum staged a major retrospective; and 1938, when the Whitney Museum of American Art presented a similar review of Duveneck's work. Denny T. Young, formerly curator of painting at the Cincinnati Art Museum, initiated this exhibition on behalf of this institution, and she guided the early stages of its development. Since late 1986, the Museum's assistant curator, Genetta Gardner, has coordinated the catalogue and exhibition. We express our gratitude to her, as well as to Carol Schoellkopf for editorial services, to Noel Martin for design of the catalogue, to Kelly Wright for editorial assistance, and to Kathy McFerron for secretarial services. The exhibition and catalogue would not be possible without the generous grant awarded the Cincinnati Art Museum by the National Endowment for the Arts. Once again, we are indebted to this federal agency for its funding participation.

An exhibition of this importance could not be organized without the generous participation of many lenders. We are grateful to the 35 lenders who have contributed so graciously. Additionally, Stanley and Frances Cohen have given financial support to the catalogue, for which we express our appreciation.

Millard F. Rogers, Jr.
Director
Cincinnati Art Museum

Preface

The Duveneck literature has been enriched by an extensive biography (Josephine Duveneck, *Frank Duveneck, Painter-Teacher*. San Francisco: John Howell Books, 1970) and a catalogue raisonné of all of the paintings of Frank Duveneck in the Cincinnati Art Museum (*The Golden Age: Cincinnati Painters of the Nineteenth Century Represented in the Cincinnati Art Museum*. Cincinnati: Cincinnati Art Museum, 1979, 45-68.) Although I have conducted research* to try to bring to light new biographical evidence and information about individual paintings, my main purpose here has been to address what I felt was the greatest gap in the literature, the need for an examination of the development of the artist's style, involving a close look at the paintings.**

I am indebted to many individuals who assisted me in the course of this project. First of all, I would like to thank Denny Young, until recently curator of paintings at the Cincinnati Art Museum. She invited my participation in the exhibition and has given me encouragement and every practical assistance along the way. Her kindness to me was shared by every member of the Museum's staff. I am also indebted to the Duveneck family, who could not have been more hospitable and helpful. I would like to thank the other private collectors and the staffs of numerous museums upon whom I called while selecting the paintings to be included in the exhibition. For their helpfulness and courtesy to me during my research, I would like to thank, among others, Brother Nathan Cochran, O.S.B., and the staffs of the Kenton County Public Library, Public Library of Cincinnati and Hamilton County, the Cincinnati Historical Society, the Archives of American Art, Smithsonian Institution, and Anne Diederick, interlibrary loan librarian at the Los Angeles County Museum of Art. Most of all, I would like to thank my wife, Mary, for all she did to assist me.

Michael Quick
Curator of American Art
Los Angeles County Museum of Art

*I did not have access to the research material compiled by Norbert Heerman, now in the possession of Bruce Weber.

**After I had submitted this manuscript I received an announcement of the publication in May 1987 of Robert Neuhaus's eagerly awaited study, *Unsuspected Genius: The Art and Life of Frank Duveneck* (San Francisco: Bedford Press, 1987). Judging from the sensitive understanding of stylistic issues the author has shown in earlier publications, it is likely that we have covered much the same ground.

Introduction

There is little in American art of the 1870s and early 1880s to compare with the remarkable paintings produced in those years by Frank Duveneck. They are outstanding both for their compelling power and for the astonishing brilliance of their technique. They prove him to have been among the most talented American artists of any period.

Duveneck's importance in the development of American art was considerable. He was among the first of what were to become many thousands of American artists who studied abroad during the last quarter of the nineteenth century. This direct exposure of a generation of young artists to the range of currents in continental art brought a relatively abrupt end to the High Victorian period of American art. Duveneck's startlingly new and different paintings, when exhibited in New York in the late 1870s, sounded the challenge to the timidity and smugness of conventional Victorian painting here. Duveneck's masterful works then drew to him in Munich and Florence scores of young artists as students, among them some of the leaders of American art at the century's end. They revered him and wrote in later years of the shaping effect his inspiring teaching had on them.

For all of this, Duveneck's reputation today is not what it deserves to be. Already by the middle of the 1880s, taste had turned strongly against the darkness of the Munich school and Duveneck's best paintings. If anything, today's taste is even more hostile to this prominent aspect of Duveneck's work. Even more importantly, the high concentration of his works in the collection of the Cincinnati Art Museum has assured that he will always be venerated locally, but this has meant that relatively few examples in other museums and collections testify to his abilities. Unfortunately, photographs and reproductions cannot serve to communicate what is most important about Duveneck's art. Seeing his astonishingly skillful and strong paintings is the proof of his greatness.

Early Life

The artist we know as Frank Duveneck was born on October 9, 1948, as Frank Decker, and when filing for a marriage license in 1886, he discovered that that was still his legal name. His father, Bernard Decker, a recent immigrant to Cincinnati from Westphalia, was a cobbler whose efforts to study law were cut short by the cholera epidemic that visited the city in 1849, when his son was not yet a year old. Earlier, in about 1830, Frank's mother, Katherine Siemers, came from the same region of North Germany with her parents, who joined a party intending to found a settlement in the frontier lands of Ohio. The family lived the hard life of pioneers in the present-day Minster, near Piqua, Ohio, especially after the death of Katherine Siemers's mother in 1840. When her father died later that year, Katherine and her sister walked barefoot to Covington, where friends of the family helped them find work. As it happened, Katherine became a servant in the household of the leading portraitist, James Beard (1811-1893). This tough and illiterate young pioneer there absorbed an interest in painting that no doubt led

her to encourage her son's emerging talent years later. She married Bernard Decker in 1848, but soon lost this first husband. During the following year, she married Joseph Duveneck, who, like her first husband, was a recent immigrant to Covington from Westphalia. He was a businessman, owner of a grocery store and other enterprises until 1860, when he built a bottling plant and opened a popular beer garden in the backyard, earning himself the nickname "the Squire." A popular man of some standing, he was elected Justice of the Peace. Joseph Duveneck was a good father to his young wife's son.

Frank Duveneck grew up within Covington's and Cincinnati's community of German immigrants, which had grown so large as to permanently affect, to the present day, the culture, customs, and even the colloquial language of the cities. He would have learned English in school, and no doubt all members of the family spoke some English, but, with a few exceptions, all of the letters that passed between Frank and his family while he was in Munich were written in German. In the mid-1870s, Frank still spoke to his English-speaking friends in a somewhat comical mixture of German and English.[1]

Perhaps because of these language and cultural differences, he seems to have grown up having little contact with the city's fine arts community. An important transportation and industrial center, Cincinnati was the fastest growing city in the western part of the country by the middle of the nineteenth century. It had a vigorous cultural life, earning the title of the "Athens of the West." Its patronage launched such native artists as Hiram Powers (1805-1873), Worthington Whittredge (1820-1910), John Twachtman (1853-1902), and Alexander Wyant (1836-1892), to name just a few of many. Duveneck can be seen as one of a long series of leading artists Cincinnati continued to produce through the end of the century.

Duveneck is said to have first shown his artistic gifts in youthful efforts at sign painting and coach decorating. These crude first attempts may have gone no further but for a curious coincidence by which his German background, which cut him off from the mainstream of the city's art activity, provided the means for his early training. The large lot at Greenup and 13th Streets that a relative had given to Joseph Duveneck in 1860, and on which the Squire had built his home and place of business, lay in the shadow of St. Joseph's Church, which dominated the surrounding German district from high ground at Greenup and 12th Streets. It was the first property purchased by the Diocese of Covington in response to the growth of the German community. The church was blessed in August 1859 and the first group of Benedictine Sisters came to teach the young Frank Duveneck and others in the parochial school and academy. One of the first priests was an artist of some reputation, and the new rector, who arrived in 1862, formed an Altar Building Stock Company to establish a workshop to produce altars for St. Joseph's and other new churches.[2] Known officially as the Institute of Catholic Art, the enterprise was part of the extensive and too-little-studied efforts of the Order of St. Benedict to embellish the many new Catholic churches being built in the country, especially those founded by the order. The order's mother church

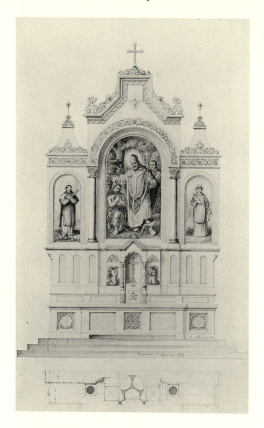

Figure 1. Brother Cosmas Wolf, O.S.B. *Design for the High Altar, Saint Boniface Church, Quincy, Illinois,* ca. 1880, pencil, ink and wash on paper, 22 x 13¼ inches. Saint Vincent Archabbey Art Collections, Latrobe, Pennsylvania.

was the Archabbey of St. Vincent in Latrobe, Pennsylvania, where Duveneck stayed at one point in his association with the organization. To head the workshop, the archabbey sent Brother Cosmas Wolf (1822-1894),[3] whose responsibilities included designing the altars and altarpieces (*fig. 1*). He employed Johann Schmitt (1825-1898)[4] to decorate and gild the altars and altarpieces and to paint some pictures. The major figural carvings were imported from Munich. Their principal painter of altarpieces and other images and decorations was the German artist Wilhelm Lamprecht, born in 1838 near Würzburg. He studied at the Academy of Fine Arts in Munich between 1859 and about 1867, then came to this country, where he painted altarpieces and church decorations in numerous cities, until he returned to Munich in 1901.[5] Others were also active in the shop, both members of the order and laymen.

It is not clear when Duveneck began what certainly amounted to an apprenticeship in the altar-making shop, whether or not it was by formal contract. However, he must have begun his training by at least 1863, at the age of 15, since the date of 1864 on an altarpiece (*fig. 2*) indicates that he had advanced to painting by that date. He first learned decorative painting, gilding, and other crafts, but then received some training in painting. No drawings after engravings or casts survive to indicate that he received a systematic course of instruction in drawing. More likely, he was taught what he needed to know in order to do the work at hand. It should not be surprising that he developed a style similar to that of his masters Schmitt and Lamprecht (*fig. 3*). Before he left for Munich in late 1869, Duveneck had advanced far enough to paint the Stations of the Cross in a large, 40 x 56 inch format for the church and to travel to distant cities as assistant to Lamprecht. He is said to have worked in Louisville, Kentucky, where the group decorated five churches, and at New Liverpool in Quebec, Newark, New Jersey, and at St. Vincent Archabbey, Latrobe, Pennsylvania. He both executed easel paintings and helped with ceiling and wall decorations. By the time he left Cincinnati, he was a working artist, who could attend with Lamprecht gatherings of the city's artists.[6]

Training in Munich

If the talented young Duveneck were to go on for further training, it was inevitable that he would choose Munich as his place of study. Given his family background, the school would have had to have been German, and given the workshop's dependence upon Munich suppliers and the fact that Brother Cosmas Wolf, Brother Johann Schmitt, and Wilhelm Lamprecht all had studied in Munich, the Royal Academy of Fine Arts in Munich would have seemed an obvious choice. Moreover, the Academy of Fine Arts had a professorship of religious painting, so that Duveneck could learn the finer points of his specialty. Already in February 1866 Brother Cosmas had formally proposed to Frank and his parents that the young man should study in Munich.[7] The parents agreed to

Figure 2. *Our Lady of the Immaculate Conception*, 1864, oil on canvas, 38 x 24 inches. Saint Vincent Archabbey Art Collections, Latrobe, Pennsylvania.

Figure 3. Wilhelm Lamprecht. *Mary, Queen of Heaven*, ca. 1860-75, oil on canvas, 86¼ x 44½ inches. Saint Vincent Archabbey Art Collections, Latrobe, Pennsylvania.

support him there for two years, and in November 1869, when he was twenty-one years of age, he began his journey. On January 10, 1870, he enrolled in the Academy.[8]

The Munich in which Duveneck arrived was clearly the art capital of Germany and one of the leading art centers of Europe. Royal patronage, particularly under Ludwig I (reigned 1825-1848), had adorned the city with noble works of public architecture, some richly decorated by the foremost muralists. The state library was among the three or four largest in the world. The university also was distinguished. The city possessed a fine museum of ancient marbles, a truly outstanding museum of Old Masters, and one devoted to contemporary painting. The bronze foundry and stained glass establishment supplied the world. The art academy was renowned, and the city was full of artists. Their population in 1890 was estimated at over three thousand.[9] Duveneck arrived at a time when the leading Munich artists were achieving great celebrity. The crop of already famous young artists produced by the Academy in the late 1860s included Hans Makart (1840-1884), Franz von Defregger (1835-1921), and Eduard Grützner (1846-1925), among many other internationally known artists. The Munich School, as a whole, was increasingly well thought of, and its artists made a point of inscribing "München" by their signature and the date on their paintings.[10]

Within the art world of Munich, the Royal Academy of the Fine Arts held a central place. With 260 registered students in the school year 1872-73, rising to 550 in 1885,[11] the Academy was a large institution relative to the size of the city's community of practicing artists. The Academy dominated art education in Munich, centralizing and concentrating it in a way quite unlike the situation in Paris, with its many independent instructors. During the 1870s certainly ninety percent of the art instruction took place within the Academy. It was a public institution, run at public expense and open to any qualified student who paid a modest fee, for up to seven years, even offering free studio space to advanced students. Foreign students in large numbers were admitted without any apparent prejudice. Even without his command of the language and familiarity with German customs, Duveneck would have received just as warm a welcome there.

The Academy had been founded in 1808 to offer instruction in the four areas of painting, sculpture, architecture, and engraving.[12] By the 1870s, the painting school was clearly dominant. Theoretical classes were offered to all students on perspective and the mathematical aspects of picture-making, on anatomy, and on art history, but the main thrust of the curriculum was the traditional sequence of drawing and painting classes. There were practical examinations for entrance into the Academy and for graduation from class to class.[13] Unlike some students, who failed the entrance examination and had to take private instruction outside the Academy until the beginning of the next semester, Duveneck passed the examination and was admitted directly to the Antique Class. On the other hand, it must have been disappointing to this practicing artist to realize that, in the eyes of the Academy, he was only a beginner. (From a historical perspective, it is possible to see that nearly all students began in the Antique Class.) Duveneck took

part in the section of the Antique Class headed by Professor Alexander Strähuber (1814-1882), one of the older faculty members. There he would have worked through a standard sequence of progressively more difficult drawing tasks, first drawing after casts of different parts of the body and anatomical demonstration casts, then after casts of ancient sculpture, and finally after heads of living models. The purpose of the course, as taught in Munich, was to train the students to see and recreate three-dimensional form, abilities that are prominent, even distinctive, in all of Duveneck's paintings. Whereas the normal length of study in the Antique Class was at least two semesters, Duveneck passed through the class in just one. He also was permitted to skip entirely the next in the sequence of courses at the Academy, the Life Class, where students drew for about two semesters from heads of models and from nudes. It is unfortunate that none of Duveneck's drawings from the Antique Class has survived, because they must have been outstanding, to have justified such rapid advancement.

Although Duveneck probably would have joined the other advanced students for the evening classes in drawing from the nude that were offered to them, his main efforts now would be directed toward painting, for in the fall of 1870 he had entered the class in Painting Technique. After he had completed that class, in his case only a year later, he would reach the final stage of the Academy's curriculum, the Composition Class, in which the student worked on finished paintings of his own design, under the supervision of the professor of his choice. It was the class in Painting Technique that changed the course of Duveneck's life.

In the history of the Academy, the class in Painting Technique was a relatively recent development that had had profound consequences for the direction of the institution and the Munich school of painting. Under the directorship of the distinguished muralist, Peter von Cornelius (1783-1867), from 1825 to 1841, the direction of the Academy had been firmly set toward preparing the students to work on mural projects and other important ideal subjects in a linear, palely colored manner. During this period, most students progressed through two courses in drawing and then directly to the master classes, learning only the rudiments of painting technique along the way. This curriculum was designed to prepare the students to work in the ideal, linear fresco style of Cornelius, rather than in the atmospheric, coloristic, illusionistic style of popular contemporary easel painting. Following Cornelius's departure, reforms were instituted to provide a better rounded training, but change was slow in coming. Wilhelm von Kaulbach, among the next most famous monumental painters after Cornelius, was appointed to the directorship in 1849, and older faculty members from the Cornelius years continued in their positions. The turning point came in 1858 when Karl von Piloty (1824-1886) was appointed to a specially created professorship so that he could lead a class in painting technique. He was Germany's most important history painter of the modern realistic style. His large, dramatic scenes, much in the manner of Paul DeLaroche (1797-1856), effectively portrayed deep shadows and bright points of contrast, rich combinations of color, and masterful effects of texture. He was a master at all that paint and color could do to convey a

powerful effect. Piloty began to teach these skills at the Academy and, during the twelve years before Duveneck's arrival, launched the instantly successful careers of many of Munich's best painters of the late nineteenth century. Piloty moved on to head a master class, but the direction of training at the Academy had changed; students were now taught to delight in skillful technique and to use it to paint powerfully realistic pictures.

Duveneck's original intentions in coming to the Academy would not have lain along these lines. He had been sent to Munich to learn to paint religious images in the accomplished style of his mentor, Wilhelm Lamprecht *(fig. 3)*. It is the highly conservative style one might expect for religious paintings during this period and represents a continuation of the archaizing manner of members of the Nazarene movement in Germany, such as Peter von Cornelius had been. It was a manner that was still being taught by the Academy's Professor of Religious Painting, Johann von Schraudolph (1808-1879), who had been appointed to his position in 1849. He undoubtedly had been Lamprecht's teacher, so similar are their approaches. Duveneck would have left Covington expecting to follow in Lamprecht's footsteps. Even though he was beginning ten years later than Lamprecht had, it still would have been possible for him to learn at the Munich Academy the same finely drawn ideal style based upon fifteenth-century models. But by 1870 the appointment of Piloty and his emphasis upon painting technique over the past twelve years had had the effect of reorienting the organization toward technical mastery and realism, and away from ideal painting. The students were astir with the excitement of what they were learning to do with the brush. The linear style of Schraudolph and the older professors came to seem to them more and more out of date.

Had Duveneck, during his second semester at the Academy, entered the large class in painting technique taught by Hermann Anschutz (1802-1880), a student of Cornelius who had been appointed as the first professor of painting technique in early 1847, perhaps his original course would have remained unaltered. Instead, he had the fortune to be among the first group of students to be taught by a young new instructor in painting technique hand-picked by Piloty, who had even executed some head studies together with him to establish the method of instruction.[14] His name was Wilhelm Diez.

Wilhelm Diez (1839-1907)[15] represented a gamble for Piloty and the director of the Academy, because he was entirely unproven in terms of the Academy's normal measures of success – critically admired, large exhibition pictures. He had studied only briefly at the Academy, by no means even absorbing the basic curriculum. Instead, he had taught himself how to paint by studying the technique of the fine collection of seventeenth-century Dutch paintings in the Bavarian museums, particularly the so-called little masters Philips Wouwermans (1619-1668), David Teniers (1610-1690), Adrian Brouwer (1605-1638), and Isaac van Ostade (1621-1649). He made his reputation as a draughtsman for popular periodicals and painted his modestly sized scenes of seventeenth-century brigands and soldiers in the fine technique of the little masters. How was such an art-

Figure 5. *The Bitter Medicine* (after Brouwer), 1872, oil on canvas, 14 x 17 inches. Dr. and Mrs Charles Carothers.

ist to teach students a universally applicable technique for the large figure studies they would be expected to execute in their class at the Academy? Within a semester it was clear that Diez's class was the most successful and popular in the Academy.

Diez's teaching had the effect of initiating a strong current in the Munich school during the late nineteenth century towards a delicate, detailed style of small-format paintings in imitation of the Dutch masters, but he had many students, and it is certainly a credit to his abilities as a teacher that relatively few of them made a career painting versions of his style and subject matter. That Duveneck may have been tempted to imitate his master is suggested by a notebook from this period, full of figural studies from, or similar to, those in seventeenth-century Dutch and Fleming paintings *(fig. 4)*. But in the end, he did not paint like his master, for we know of no paintings of this type by Duveneck, except for a copy of a Brouwer *(fig. 5)*.

The two very basic elements of Diez's approach that all his students do seem to have absorbed are imitation of the Old Masters and a deep interest in technique, per se. One sees ever again in the work of the Diez students the Dutch ruffs, pipes, and costumes, even certain physical types, as well as more important borrowings, such as special types of lighting. Surprisingly few copies of Old Masters done in their school years by Duveneck and his classmates have come down to us,[16] but their own paintings bear witness to their study of the Old Masters and strong preference for one or the other at different times. The fascination with technique which Diez instilled in his students seems to have been the force

Figure 6. *Head of an Old Man in a Fur Cap,* 1870, oil on canvas, 23⅞ x 19½ inches. Cincinnati Art Museum, 1915.112.

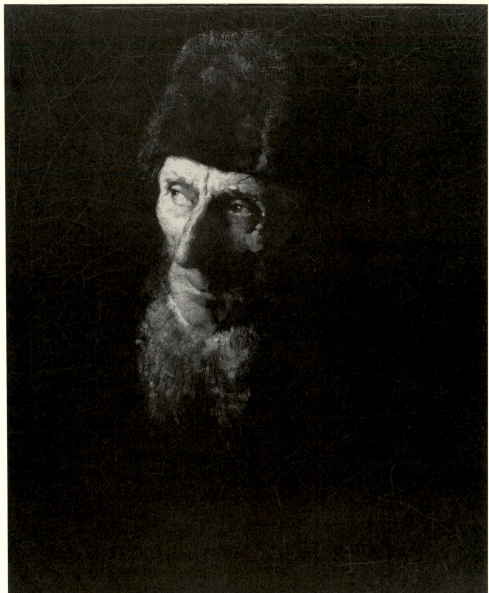

Figure 7. Ernst Zimmermann. *Man with Fur Cap.* Unlocated. (Reproduced from old photograph).

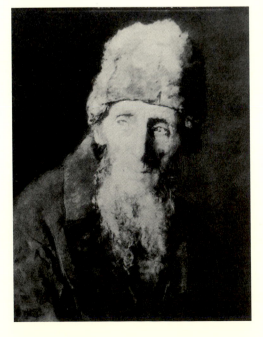

which drove the class forward, seemingly as an evolving experimental process. Diez fostered a give-and-take among the students, whose enthusiasm grew as they worked together on technical investigations and experiments. Duveneck here began his mastery of painting technique, almost in the abstract, that made him such a remarkable painter and effective teacher. Diez's students were enthusiastic about the class and loyal to their master. When Diez was apparently passed over for a permanent appointment in 1871, his students wrote a petition to the king.[17] The first name of a long list of signatures was that of a titled student, but the second and largest was that of Frank Duveneck. He was a favorite of Diez's, and they became very close.

Students swarmed to join Diez's class, the sensation of the decade at the Academy. The faculty was equally impressed with the results of the first year's work, when shown in the examination exhibition at the end of the semester. The whole class was accorded official praise, and as an exception, seven silver medals were authorized for individual students, instead of the usual bronze ones given to students in the classes in painting technique.[18] One of them went to Duveneck, who proudly wrote to his parents about the unexpected honor.[19]

The few works by Duveneck surviving from these very first years as a student of painting afford a glimpse of what was taught in the class. The earliest is his *Head of an Old Man in a Fur Cap (fig. 6)*, painted in 1870, during his first semester with the class. A painting of the same model in the same costume *(fig. 7)* by Ernst Zimmermann (1852-1901), a just slightly later student in the class, establishes this as a class exercise. In fact, a study *(fig. 8)* by Ludwig von Langenmantel (1854-1922), a student in another painting class, suggests that this may have been a study in form and textures that was used in all the classes, perhaps inspired by a painting, now in the Lenbachhaus, then thought to be by Rembrandt. Comparison of the two Diez class studies with the one by Langenmantel points to a fundamental difference: the Diez class studies are not the clear, cool, somewhat dry studies of shapes and volumes one would expect from a basic painting class. These studies are already full of drama and interpretation. With their alphabet, the students were learning the use of exclamation points and question marks. They were taught from the beginning to paint forms in terms of light and circumstances of seeing, with all of the interpretive potential special lighting has always meant in the history of art.

Even within such a context of interpretive studies, Duveneck's classmates must have marveled over the tender pathos of his *Portrait of a Young Man Wearing a Red Skull Cap (pl. 1)*, dated 1871. The form of the head is quite distinct and solid, despite the softness of the brushstrokes, meant to suggest a delicate effect of dim lighting. The head is what is so rare among students' work, a study of character. Already, in this second semester of his painting class, one can discern the two essential qualities of Duveneck's finest later work — the way the brushstroke itself holds one's interest and the precision of the characterization.

That the students learned technique for every situation is demonstrated in Duveneck's full-dress academic study, his *Caucasian Soldier (fig. 9)*. It is clearly

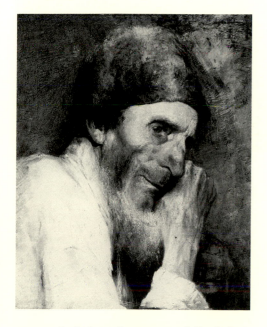

Figure 8. Ludwig von Langenmantel. *Head of a Man*, 1875, oil on canvas, 18⅞ x 15¾ inches. Städtische Galerie im Lenbachhaus, Munich.

Figure 9. *Caucasian Soldier*, 1870, oil on canvas, 50¼ x 41¼ inches. Gift of Miss Alice Hooper. Courtesy of Museum of Fine Arts, Boston.

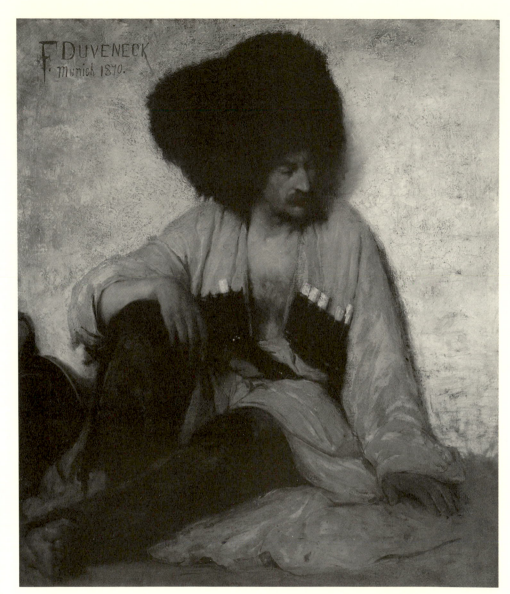

Figure 10. August Holmberg. *Tscherkesse*, 1871, oil on canvas, 59 x 48½ inches. Unlocated.

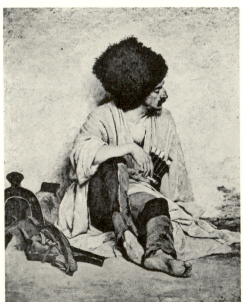

Figure 11. *Head of a Girl,* ca. 1872, oil on canvas, 27⅞ x 21⅛ inches. In the collection of The Corcoran Gallery of Art, Museum Purchase, Gallery Fund.

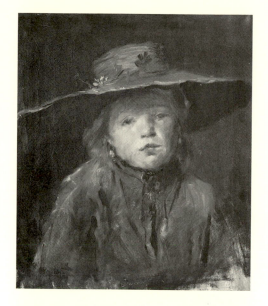

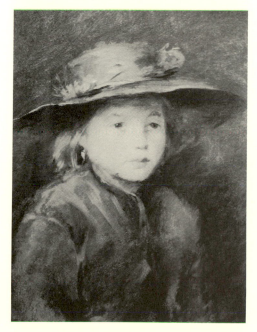

Figure 12. Alphons Spring. *Young Girl with Hat,* 1872. Unlocated. (Reproduced from old photograph).

dated 1870, but the fact that a painting by August Holmberg (1851-1911) of the same model in the same costume and precisely the same pose *(fig. 10)* is dated June, 1871, suggests that Duveneck's painting may also be of that later date. It shows such advance over his first semester's work. The problem presented by the exercise is to paint a complicated form over a full range of values from bright light to deep darks, while establishing an overall effect of lighting for the figure. With virtually no cast shadows, the shapes must be developed by drawing and by secondary areas of shade within the figure. In effect, the shadowed elements are subordinated, being drawn and roughed in in terms of a few highlights, while the lighted areas are given greater definition. Here one sees, for the first time, the grasp of form and ability as a draughtsman that had won Duveneck such rapid promotion from the drawing class, especially in the hands and the foreshortened arm and foot. The painting technique is appropriately varied and surprisingly vigorous in places, such as the highlighting of the upper garment and the richly textured wall.

As accomplished as this demonstration piece is, the painting that could have won Duveneck his silver medal in July 1871 was *The Old Professor (pl. 2).* Where the large painting demonstrates competence, this commands attention. The subject was the Munich apothecary Clemens von Sicherer, who had posed for Wilhelm Leibl (1844-1900) about 1865 and also for Wilhelm Trübner (1851-1917), wearing the same wide, black cravat that seems to separate the head from the sloping shoulders. His uncompromising frontality in Duveneck's portrait certainly contributes to its impressiveness, as does the contrast of the lighted part of the face against the deep background. What drives home this impression, however, is the raw vigor of the paint handling. Compared to this, the technique of his *Whistling Boy (pl. 3)* seems poised and elegant.

Head of a Girl (fig. 11) suggests the final stages toward the classic style of the paintings of 1872 and 1873. It has often been dated later in the decade, but the date of 1872 on a painting of the same model wearing the same hat *(fig. 12)* by a classmate, Alphons Spring (1843-1908), establishes for Duveneck's painting this earlier dating, which fits better into the development of his work. Certainly no execution this tentative could belong to a work of the later part of the 1870s. In *Head of a Girl,* Duveneck was investigating another approach to the class's primary concern with a systematic, unified scheme of modeling for the entire figure. His earlier efforts had been modeled in terms of light and dark. In this exercise, he modeled in terms of cool tones for the dimmer areas and warmer ones for the lighted portions. The effect of lighting is much less pronounced in this painting, because the artist has avoided working in terms of extreme shifts of value. The transitions are also less extreme than in *The Old Professor,* for instance, because there must be a certain degree of blending of the cool greys and warmer tans and pinks to retain a naturalistic appearance. This approach to modeling by means of warm and cool colors was based upon Diez's study of the Dutch Masters. It was to grow in importance in the teaching of the Academy, particularly during the 1880s, but it seems not to have been pursued as an exclusive method by Diez's

earliest students. Perhaps it seemed pallid to these excitable young men, who had already cultivated the drama of strong lighting. The following story may describe Duveneck's role of leadership at this juncture:

> Diez was a bitter enemy of all "sweet colors", for which he could forgive not even the best artists. All his students aimed primarily at a "fine tuning" of their painting, so that the entire school eventually deteriorated into complete greyness. The timid souls could only feel good, and safe from "sweet colors", by painting effects of dimness. The talented American, Duveneck, was the one who decided to stage a decisive revolution against this state of affairs. He covered his canvas with pure cinnabar, put some bright white on it, and painted a head in this key. To our current way of thinking, it shone dreadfully, naturally making all previous studies seem even greyer than ever. We all ran together to see it. Diez was delighted. He made a real cult of Duveneck and hung up in the studio this epoch-making head, while we all went to buy cinnabar. Now we worked on impressive effects; the grey-painting was out of date.[20]

Whether as a result of the attempts to model in warm and cool tones, or in spite of them, color began to play a central role in Duveneck's further work.

The first masterpiece of Duveneck's early years in Munich is *Whistling Boy (pl. 3)*, which bears the date of only 1872. In July 1871 Duveneck had graduated from the class in painting technique and then advanced into Diez's Composition Class, or master class, when the Academy reopened at the beginning of October. At this stage of their instruction, students painted head and figure studies at first, but then progressed to painting completed, saleable works, under the supervision of the professor. In the earlier days of the Academy the students had worked on ambitious religious or historical compositions, but in Diez's Composition Class the students painted mostly genre pictures. *Whistling Boy* and *Lady with a Fan*, 1873 *(fig. 13)*, were such genre pictures, painted while Duveneck was working in a class, but on his own initiative. Before the thin paint of the smoke turned transparent, the so-called whistling boy appeared as a young tough blowing smoke through his lips. The bold young apprentice in an apron and carrying a basket is a familiar subject of Munich genre painting.

Like all his other works of this first phase of Duveneck's Munich period, *Whistling Boy* is conceived in terms of a strong, unifying effect of light and dark. The figure seems to emerge from an envelope of darkness and atmosphere that obscures and softens parts of it. The principal light falls on the face, which is not only lighter than other portions, but also more detailed and stronger in color. In *Lady with a Fan* and the *Portrait of Professor Ludwig Loefftz (pl. 4)*, one can see this same three-part system at work, comparing the value of the faces and the degree of detail there with the hands, for instance, and the relative strength of the color in the face and hands.

Whistling Boy is different from the other two, however, in the energy and con-

spicuousness of its brushwork. This is most obvious in the peripheral areas of the body, meant to be softened and obscured by dense, intervening atmosphere. The sleeve and basket almost completely lose their form in a flurry of distinct, blocky, criss-crossed brushstrokes. Even on the face, though, the brushstrokes are prominent enough to seem to facet the form in places, creating abrupt changes in value and color, rather than the smooth transitions to be expected in a finished painting. This degree of prominence of brushwork in a finished painting, to the point that it asserts itself against the illusion of solid form, is rare in German painting in this period. It raises the question of the influence of the brilliant young painter, Wilhelm Leibl (1844-1900), and the circle of gifted artists who worked in very close association with him in Munich from 1871 to 1873. They were studying the works of the Old Masters at the same time that Diez and his class were, so there is a general similarity among the works of the two groups that has led to uncertainty over the years as to who influenced whom, and to what extent. What sets Leibl and his circle apart from the Diez class and, indeed, almost all Munich artists at that moment, was the extent of their exposure to contemporary French painting. It is not so much that their paintings look French, which they certainly do not, but that they embody certain advanced French attitudes toward art.[21] At its most basic, what they borrowed from the French was the concept of *l'art pour l'art*, that what is important in a painting is how it was painted. The artist's use of composition, color, and technique in a beautiful and expressive way was a sufficient end in itself, regardless of the importance of the subject or the success of the pictorial illusion. Such attitudes stand behind the conspicuous, even assertive technical displays of *Whistling Boy*, especially in the face, where the artist preserved the evidence of his elegant paint handling, at the expense of the illusion of flesh and rounded form. The spirited sketchiness of most of the painting is very much in the spirit of Leibl and his circle. Its energetic diagonal strokes and highlights recall the work of Frans Hals, the Old Master whose scintillating brushwork was much admired by Leibl. Later in life, Duveneck remarked of Leibl: "That man had more influence over me than any of the other men in Munich, although I never studied with him."[22] Such a statement, coming after a lapse of time and after Leibl's rise to international fame, must be read with caution. Much more persuasive is the fact that in October 1872, Duveneck exhibited three paintings at the Kunstverein, one of them sketchy and unfinished. The painting provoked protest, and two reviewers connected Duveneck's name with that of Leibl.[23] In July 1871, Duveneck had also drawn attention to himself with "a study *(Head of a Girl)* which I painted in a half hour."[24] Moreover, in an undated letter to his parents that reports the strong reaction to his unfinished paintings at the Kunstverein ("three portraits that I painted are now causing a great furor"), he mentions the name of Leibl in another passage: "A short while ago, listening to strong recommendations, I had decided to travel to England and paint portraits. Prof. Diez and Leibl have counseled me to remain here and work [on a major painting] for the exhibition in Vienna."[25] This sentence suggests that Leibl, more than just an acquaintance of Duveneck's, was to some extent a mentor. How this

relationship, if that is what it was, came about at this point is unclear. Although Diez is known to have associated with Liebl, apparently not all of his students shared that acquaintanceship.[26] In any case, it was the beginning of a continuing current of American interest in Leibl. William Merritt Chase (1849-1916), apparently at some sacrifice, purchased two small paintings by Leibl while Chase was still a student in Munich. Leibl painted the portrait of the American student Jean Paul Selinger (1850-1909) in about 1874-75. The first extensive article on Leibl was published in *The American Art Review* in 1880.[27]

Whistling Boy is the most conspicuous embodiment of Leibl's direct influence on Duveneck. It had been an important step in the young artist's development, but the influence did not long remain so clear or strong. In some ways, however, at a more fundamental level, it was a shaping experience of lasting significance. This is most true of the attitudes toward technique that Duveneck would have first heard from Leibl. Leibl and his circle felt strongly about the integrity, or honesty, of their technique. They believed that a picture should frankly show the way it was painted. This meant that the picture, as a whole or section by section, should be painted *alla prima,* which is to say, finished in one session, wet into wet, without the customary stage of overpainting or glazing to correct and harmonize what had been painted first. Evidence that Duveneck absorbed these attitudes of the Leibl circle can be found in his *Portrait of Professor Ludwig Loefftz* of about 1873 *(pl. 4),* which is a *tour de force* of *alla prima* painting. The story has come down to us that Duveneck painted this portrait all day long, completing it when he and his sitter were exhausted.[28] When he exhibited it in 1875, Duveneck made a point of stating that it was painted in one sitting.[29] (A technical examination of the painting indicates that it probably was painted all at one time.) There would have been little incentive for Duveneck to attempt such a heroic feat did he not share the strong feelings of the Leibl circle against overpainting and glazing. The painting, poised and tranquil, does not present itself as a manifesto of principles, but when one realizes how it was painted, it seems all the more remarkable. The skillfulness of the brushwork, the vividness of the detail, and the clarity of observation that enabled Duveneck to mix the colors of the face so exactly the first time, show him to have been, already at this point in his career, an absolute master of technique, equal to the greatest challenge that could face a portrait painter. The *Portrait of Professor Ludwig Loefftz* is a completely finished painting, indeed, a noble one, carried out according to the most demanding technical standards.

In almost all of his work before 1883, Duveneck adhered to the strict injunction of the Leibl group against overpainting, and he took pride in painting many of his more modest works in a clearly *alla prima* manner. One senses in all his works and in his teaching a strong consciousness of the beauty of the way in which things were painted.

Another important work of Duveneck's first period in Munich is *Lady with a Fan,* 1873 *(fig. 13),* a genre painting (rather than a portrait). In the spirit of imitation of the Old Masters so strong around him, Duveneck based the pose of this

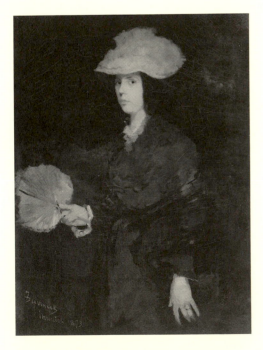

Figure 13. *Lady with a Fan,* 1873, oil on canvas, 42¾ x 32¼ inches. Metropolitan Museum of Art; Gift of the Charles F. Williams Family, 1966.

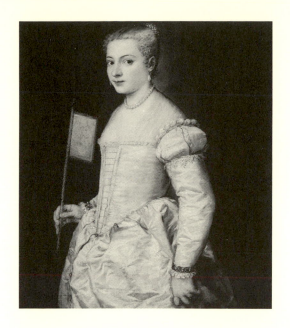

Figure 14. Titian. *Portrait of a Girl*, ca. 1555, oil on canvas, 40⅛ x 33⅞ inches. Dresden, Gemäldegalerie Alte Meister, Staatliche Kunstsammlungen.

subject, but not the style, on a painting by Titian *(fig. 14)* of a lady with a flag-like fan. It is a full-dress painting by a fully accomplished artist, a graceful and fascinating image elegantly painted. In strong contrast to *Lady with a Fan's* careful subordination of elements and unity and to its subtle mood is the *Head of a Girl*, 1873 *(pl. 5)*, an unfinished study, abandoned at the point where Duveneck had established the overall effect of lighting and the major planes of the face. The artist must have considered the energy of the sketchy beginning sufficiently interesting to be worth preserving. It is one of the earliest works to show the arrested early stages of his mature painting technique.

Duveneck had achieved success in terms of his friends and his professors. Moreover, during the summer of 1872 he was able to earn 1200 Gulden with "saleable pictures" (whatever they might have been),[30] although his finances at other times may have been tight. One of the most romantic indications of Duveneck's success is contained in an undated letter, probably from early 1872, following Duveneck's return from a month-long trip to Venice and Trieste:

> When I returned to Munich and looked up my classmates, I was
> congratulated on all sides and asked if I knew the news, that the painter
> Lenbach, after he had seen a few of my portraits, had invited me to take a
> place next to him in his atelier. Naturally, quite flabbergasted, I ran
> immediately to Professor [Diez], who greeted me in the most affectionate
> manner and said, "Duveneck, you are the crown of my school. My
> associate, Master Lenbach offers you a place in his atelier, soon or in a
> short while. Just now he is not here in Munich, because the Emperor of
> Austria summoned him to paint his portrait. When he returns, you and I
> will go to see him, right away." Should this truly come to pass, I would be
> thrilled, since such an opportunity only comes to the likes of Van Dyck.[31]

Franz von Lenbach (1836-1904), who painted the Emperor's portrait in late 1871 and early 1872, had already distinguished himself as the foremost portraitist in Munich and perhaps in Germany. To have painted by his side must indeed have seemed to Duveneck like the situation of Van Dyck when he was taken up by Rubens.

The reported offer from Lenbach never came to pass, and other bright promises of success during Duveneck's first period in Munich likewise came to nothing. At the end of the first semester of the school year, 1872-73, Duveneck won an important honor, when his composition sketch was chosen as best in an Academy-wide competition on the subject of a scene from Goethe's *Götz von Berlichingen*. The contest was all the more important since it did not take place every year. The two top prizewinners were given a studio and expenses for models. The one who completed the best large finished painting was awarded the prize. In this case Benesch Knüpfer (1848-1910) won the prize of 300 Gulden when he finally completed his large version in 1876. The official report[32] indicated that Duveneck's return to the United States had prevented his completing his, but there is actually no evidence, in documents or letters, that Duveneck ever began it. A surviving oil sketch for a genre or historical painting (Private Collection, Cincinnati), dated 1873 indicates that Duveneck made at least some efforts at this kind of painting, but it could well be that, when facing the challenge of a highly visible commission, he did not feel he had the proper training, or perhaps he saw no advantage in the task. Such an opportunity would have launched the career of a student in Paris, but the market worked differently in Munich. A parallel case to Duveneck's was that of William M. Chase, who did not carry out the commission he won with his composition sketch from the life of Columbus in a later contest.

Harder to understand is Duveneck's failure to complete a painting for the important Art Exhibition in Vienna in 1873. In this case, he could have shown a genre painting, or even an ambitious portrait, rather than a historical painting. The exhibition was the most important artistic event for Munich artists in several years. In early 1873 vigorous protests broke out among the German artists who felt too little space had been allotted to them. All of the best artists were working on something for the occasion. Among Duveneck's classmates in the Diez Composition Class, Löfftz, Spring, Holmberg, Robert Schleich (1845-1934), and Victor Weishaupt (1848-1905) showed works in the exhibition, the first four of them receiving awards. In about October 1872 when he was accorded a place in the exhibition, Duveneck was full of determination and high hopes:

> Today I was awarded a place in the Vienna World Exhibition. I hope that I will win something there, because then I will be secure for the rest of my life. The only thing necessary is that I should win the first Gold Medal.[33]

Within six months, however, he had given up on having anything finished in time for the exhibition. Part of the problem may have been his fear of falling short

of the promise he had already shown. "If I were to send something to Vienna, it has to be either good or nothing at all. Otherwise, I would make a fool of myself before the other artists, with whom I have now earned a considerable reputation in such a short time."[34] For whatever reason, Duveneck's first period in Munich ended without a major work that fulfilled the bright promise shown in *Whistling Boy* or that gave full scope to the consummate technical mastery demonstrated in his *Portrait of Professor Ludwig Loefftz*. Seeing what he could do, one has to regret that, through his entire Munich period, and until his style and aims changed in Italy and Paris during the 1880s, Duveneck carried to completion so very few major statements such as *The Turkish Page (pl. 6)*, being content with a wonderful series of more modest works, painted brilliantly for the approval of the artists, the true connoisseurs. Already in late 1871 or early 1872 he expressed this point of view in a letter to his parents: "...especially among the artists, who really are the only ones for whom I worked. The main thing is the respect of the artists. One easily wins the respect of the public, because they don't understand anything."[35] Duveneck continued to work according to this high standard, but the relative lack of exhibition pictures among his work has hurt his reputation in recent times. So many of the public still walk by the marvels of painting that hold the artist and connoisseur enthralled.

Return to Cincinnati, 1873-1875

There were probably several causes that led to Duveneck's return to Cincinnati late in 1873. His parents had agreed to support his study in Munich for only two years, so already in 1872 he had to justify to his parents his continued stay. As time passed, they increasingly felt that it was time he earned a living and perhaps helped support the education of his brothers and sisters. In April 1873 his stepfather wrote:

> It appears that you do not succeed very well in making money as the painters Schmitt and Lamprecht do. The rascals are getting as rich as Rothschilds. Lamprecht has made money enough to live on the rest of his life and doesn't need to work anymore. His assistant, too, is getting along splendidly. All the artists say that you ought to come home.[36]

Fear of the cholera epidemic in Munich is sometimes given as the reason for Duveneck's departure, but that would seem unlikely. The artists of Cincinnati gave a welcoming reception for Duveneck on December 17, 1873.[37] This means he must have left Munich during early November, when cholera no longer seemed a threat.[38]

His main reason for returning to Cincinnati may have been to earn some money, on a short-term basis. He remained tentative about whether he would stay in this country, at the time of his arrival.[39] His friends in Munich had given him a farewell celebration, and ridden part of the way with him on the train.[40] He

returned to his native city crowned with honors, cutting a stylish and worldly figure in his Munich tailoring (fig. 15).

Given his earlier associations among church decorators, it might have been expected that such work would easily come to him and even could have been offered to him as an inducement to return, but his motives must have been more than a little mercenary, for him to have resumed the kind of work he had foresworn after arriving in Munich, according to a letter to his parents written in 1871. He again expressed a reluctance to return as a church decorator in a letter datable to the following year.[41] But he apparently spent a good part of his time once again carrying out church and other public decorations. None of these decorations is known to have survived. According to contemporary observers, they represented a break with all that Duveneck had achieved and valued in Munich:

> *The figures [in the chancel of the Church of the Holy Trinity, Cincinnati] are colossal in size, but there is nothing in the design or execution that would enable any one familiar with his style to recognize these paintings as his work. He evidently fell back into the conventional mode with which he was so well acquainted, and executed a fair work of its class, but nothing more. The costumes of the adoring choirs, in the spandrils at the right and left of the chancel, are in form and color sufficient to raise a smile upon the faces of those who know the artist by the paintings that identify him in the minds of art connaisseurs [sic].[42]*

Of course, it could not have been otherwise. Once he had agreed to do the work, he had to carry it out according to the conventions and established style clergymen and parishioners expected to see in churches.

It is said that Duveneck traveled to Chicago to decorate a church and then to St. Louis and Kansas City painting protraits.[43] More firmly established is that his father, on April 28, 1874, wrote to him in Evansville, Indiana,[44] where on May 10, the *Cincinnati Commercial* reported he was "engaged in two large Bible scenes for St. Mary's Church." Apparently he had not forgotten all that he had learned in Munich, because while there he carried out a portrait of the pastor, "painted by Mr. Duveneck at one sitting and completed in three hours." The *Cincinnati Enquirer*[45] recorded on June 19, 1874, that he was once again in Cincinnati, where he had "just finished and sent to Chicago a large painting of Christ delivering the keys to St. Peter. It will be the altar piece of St. Peter's Catholic Church in the Lake City." Whether he had also already been to Chicago to paint wall decorations in the church is not indicated. During the late summer he must have been completing his decorations in the Grand Opera House that received a harsh review in the *Cincinnati Enquirer* on September 6, 1874:

> *We had hard words of criticism, and we still have them for the artist (?), so-called – Mr. Duveneck – who did the figure work by – forced-sub-contract under Mahler & Tepe, who did the ceilings. But those ceilings light up*

Figure 15. Portrait of Frank Duveneck, taken in Cincinnati, ca. 1874, Frank Duveneck Papers, 1851-1971, Archives of American Art, Smithsonian Institution.

grandly, in spite of the blots upon them....There are busts of Haydon [sic], Weber, Mozart and Beethoven, and four figures, one of Comedy, Tragedy, Art and Music. Over the proscenium...is an infant bard, another of Duveneck's masterpieces.

Duveneck must have spent much of September 1874 working on his decorations for the Church of the Holy Trinity in Cincinnati *(fig. 16)*. He was working as a partner or employee of William Dean,[46] a specialist in large decorative projects The *Enquirer* had kinder words about Duveneck in its issue of October 11, 1874:

Mr. Duveneck was the artist chosen to adorn the sanctuary walls on either side and above the gigantic apcess [sic] in which the altar stands. His designs and their execution really do him credit, and have fairly convinced us of his capability to perform an infinitely better class of fresco-work than might have been supposed from the character of his recent Grand-Opera-House decorations. The frescoes commence immediately over either side altar, extending to the apex of the arch above; and represent the nine choirs of angels in tunices [sic] emblematic of their respective celestial Orders. There are in all about twenty figures, the lower one on the right-hand side being nearly fifteen feet in height; all being angels in rainbow-colored raiment on a gold ground. They are represented in kneeling attitudes on a kind of carpet, strewing flowers; and rise above

Figure 16. Interior of the Church of the Holy Trinity, Cincinnati (demolished). Photograph courtesy of Archives of the Archdiocese of Cincinnati.

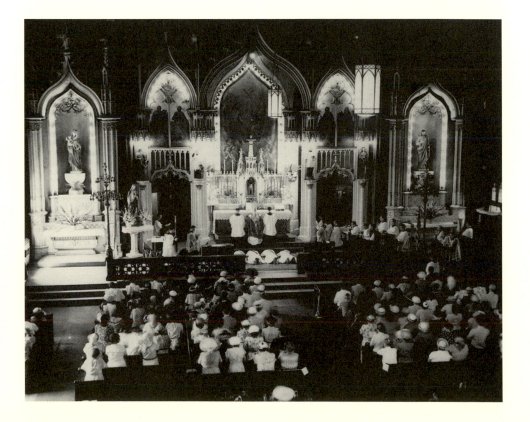

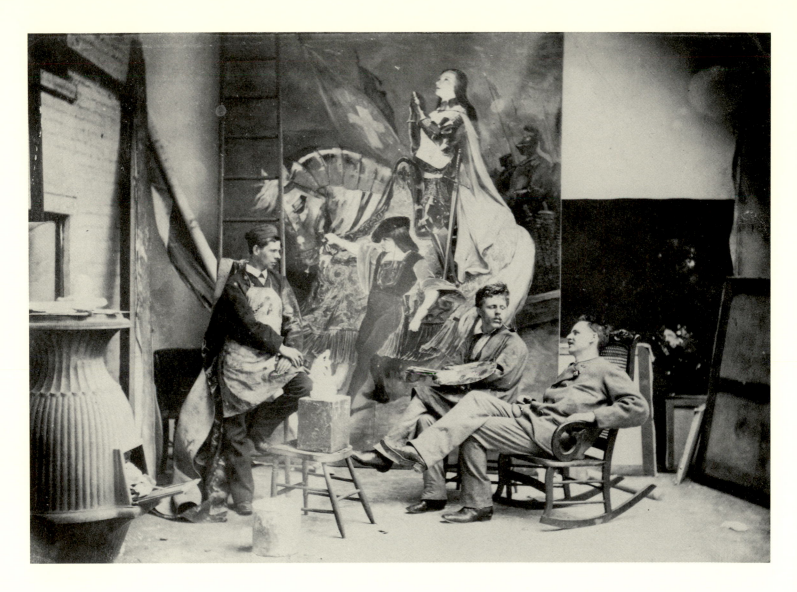

one another in decreasing perspective toward the ceiling, melting away at last into a cloud of cherub-heads and wings. The excessive brilliance of the coloring has been found fault with; but Gothic interiors allow of florid ornamentation, especially in the sanctuary of churches, and the gorgeous design harmonizes well with the surroundings of that part of the chapel. The painting had indeed been sharply criticized, yet considering the very unfavorable circumstances under which the artist labored — extremely poor light, clumsily intricate scaffolding, etc. — he is not to be blamed for any trifling defects that may exist in the work.

What was perhaps his last effort at decorative painting while on this visit to Cincinnati can be glimpsed in a photograph (fig. 17) of Duveneck in his studio. Entitled *The Prayer on the Battlefield*, and representing Joan of Arc returning thanks for her victory, it was designed and painted by Duveneck and Henry Farny

(1847-1916) during the middle of May 1875 for the French booth at a festival in Cincinnati. It would appear to have been unlike his church decorations, however, and more in the style of history painting in Munich and the large festival decorations often painted by the art students there. During the winter of 1874-75, Duveneck shared this studio with Farny, the figure in the rocking chair, a Cincinnati native whom he had met in Munich, and the sculptor Frank Dengler (1853-1879). Except for the fact that his promising career was cut short by consumption, Dengler's life had been remarkably similar to Duveneck's. Raised in a German Catholic community, he had received his earliest instruction in a firm that carved images for churches. He then won top honors at the academy in Munich. Again like Duveneck, he received little patronage when he returned to Cincinnati, but was accorded enthusiastic recognition in Boston.[47]

That same winter Duveneck began what was to be a long career as teacher. He taught a life class at the Ohio Mechanics Institute School of Design.[48] Among his pupils were Kenyon Cox (1856-1919), Robert Blum (1857-1903), and Joseph DeCamp (1858-1923), and also John Twachtman, who accompanied Duveneck back to Munich and became a close associate and friend.

Cut off from the stimulating environment of his Munich classmates and reduced to what must have seemed the mechanical drudgery of church decoration, Duveneck very easily could have ended his stay in Cincinnati considering it to have been a waste. The few known portraits from this period, however, show striking advances in the development of his style. Of these, the least different from his earlier work is the *Portrait of Frances S. Hinkle*, 1875 (fig. 18). No doubt a commission, it is in a more conservative and more flattering manner. Here, for the first time, is what was to become Duveneck's characteristically clear sense of sculptural form in the head and hands, but the soft handling suppresses most detail, very likely a charity in a portrait of this older woman. Although the subject faces forward, the eyes seem slightly averted, and the warm side lighting mitigates the uncomfortable frontality of the other portraits in the group.

Quite different is Duveneck's style in a portrait which he exhibited and sold, and which therefore probably was not a commission, the *Portrait of William Adams*, 1874 (fig. 19). It has a somewhat freer brushwork than some others of this period, but like them is distinguished by a new quality of forceful realism. A stronger, but not obtrusive, frontal light pushes back the encroaching shadows found in works of the previous year, lending the head, especially, a more solid and plastic quality. The face is high in color and pointedly realistic, sharp lines tracing wrinkles and unsparingly recording the effects of age in the sunken features and mouth. Duveneck's aptness in posing his larger figures is seldom noticed, but is evident if the youthful poise of Ludwig Löfftz is compared with this old man's fragile uprightness in his too-large clothes and old-fashioned chair, bespeaking a simpler era.

A more modest work, but apparently the first to show the extent of the change in style during the Cincinnati period is the *Portrait of Henry L. Fry (fig. 20)*, prominently dated on its elaborately carved frame, 1874. In it, individual brushstrokes

Figure 17. Photograph of Frank Dengler, Frank Duveneck, and Henry Farny in Duveneck's and Dengler's studio in Cincinnati, 1875.

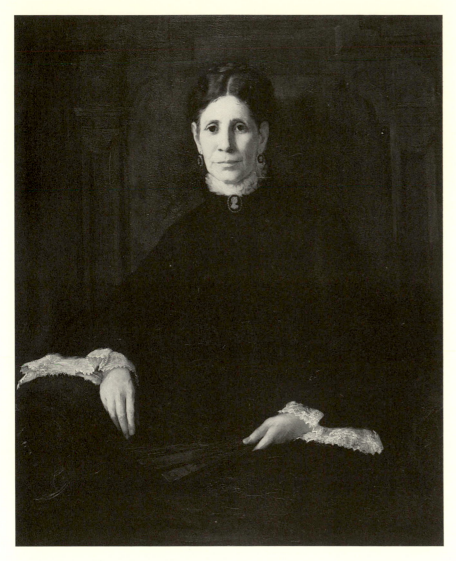

Figure 18. *Portrait of Frances S. Hinkle*, 1875,
oil on canvas, 43³⁄₁₆ x 35 inches. Cincinnati Art
Museum, 1926.16.

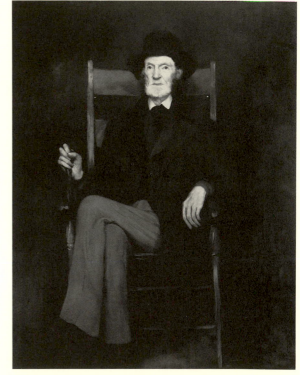

Figure 19. *Portrait of William Adams*, 1874, oil
on canvas, 60⅛ x 48¼ inches. Milwaukee Art
Museum Collection, Milwaukee; Gift of Mr. and
Mrs. Myron Laskin, Mr. and Mrs. George G.
Schneider and Dr. and Mrs. Arthur J. Patek, Jr.
in memory of Dr. and Mrs. Arthur J. Patek.

have lost their identity, merged in an effort at complete illusionism, which serves an unsparing realism. The subject gazes unflinchingly at us, and we at him, at the bags under his eyes and folds of skin that hang down over their outer corners, at the wrinkles and signs of age. Remarkably, there is a degree of pathos and a strong sense of personality that ameliorates what in other hands could have been a dehumanizing naturalism.

Probably because he knew the subjects so very well and abundantly felt their personalities in his characterizations, the most powerful and the finest portraits of the Cincinnati period are the portraits of his father (fig. 21) and mother.[49] They are strongly lighted, full-face portraits that record every detail of the faces with an unsparing bluntness. His florid complexion and the signs of age in the face of Squire Duveneck make his portrait seem the more realistic of the two, but a close examination of the mother's portrait discloses an equal degree of precision, notably in the shaping of the nose, the color and folding of the eyelids, and the finely drawn lips. No trace of the brush distracts from this complete illusion. This degree of searching realism is so unusual in portraiture that it can make the viewer somewhat uncomfortable. It would seem brutal in this case, were the characterizations not equally vivid — the large, outgoing man of business with a somewhat introspective nature, and the simple, honest, strong-willed woman.

Among the known paintings from Duveneck's first Munich period, there is nothing to compare to these Cincinnati paintings. The graceful, soft brushstrokes and sense of enveloping mystery in the Munich paintings are utterly unlike the complete illusionism and fierce realism of the portraits that followed his return to his native city. It would be unusual for an artist to make a major stylistic shift like this just when he was removed from a varied and stimulating artistic environment and placed in a more limited one, so one has to wonder how this change in Duveneck's work came about. Even more curious is the fact that it was in the very years when Duveneck was away from Munich, 1874-75, that a shift toward a tighter manner of brushwork and more forceful realism occurred in the work of some artists there, for instance, Leibl and William Chase (fig. 22). Since so few paintings by Duveneck from his first Munich period are shown, it is possible that he began this stylistic transition there in works that are now lost.

Although Duveneck pursued a more realistic style during his second period in Munich, those paintings are unlike the Cincinnati portraits, showing a greater complexity and sophistication. The Cincinnati paintings have a curiously homespun and personal quality of realism that is especially evocative.

When interviewed in 1881, Duveneck complained bitterly about the lack of patronage in Cincinnati, which he may have experienced directly.[50] He never had a proper exhibition of his paintings, except in a store window, but remarks in contemporary sources indicate that he did not receive an appropriate degree of appreciation.[51] In striking contrast was his reception in Boston, where he exhibited paintings in May-June-July 1875, and again in August-September.

For a city in its region, Cincinnati had an exceptional amount of artistic activity and sophistication, but it was not to be compared, in either respect, with

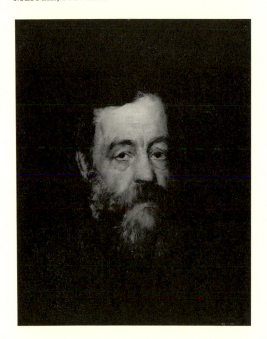

Figure 20. *Portrait of Henry L. Fry*, ca. 1874, oil on canvas, 19¹¹⁄₁₆ x 16³⁄₁₆ inches. Cincinnati Art Museum, 1907.193.

Figure 21. *Portrait of Squire Duveneck*, 1875, oil on canvas, 30 x 25 inches. Rosenberger Gallery, Centerport, New York.

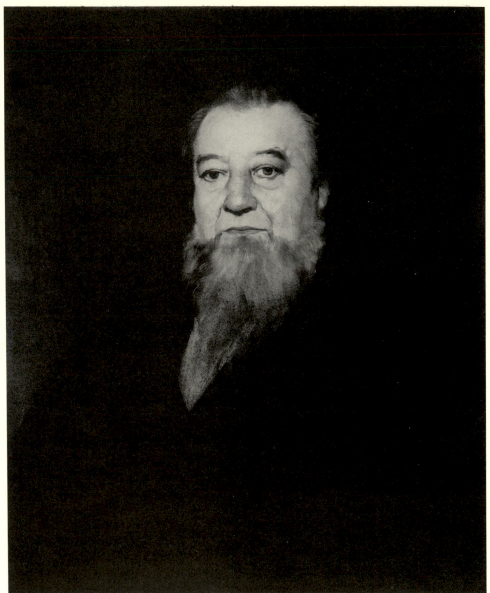

Figure 22. William Merritt Chase. *Keying Up – The Court Jester*, 1875, oil on canvas, 39¾ x 24⅞ inches. Courtesy of the Pennsylvania Academy of the Fine Arts.

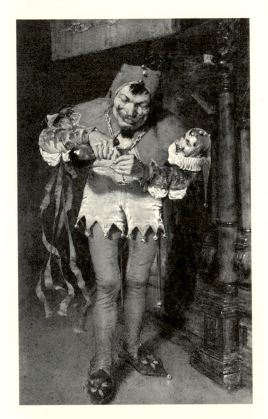

Boston, an older, wealthier city with an unmatched depth of artistic tradition. In more recent years the painter and teacher William Morris Hunt (1824-1879) had developed in his fellow citizens a strong taste for the current style of French painting. Duveneck's reception in Boston was an informed one, and its warmth that much more significant. The critical response was extensive and uniformly enthusiastic. All but perhaps one of the paintings were sold, and Hunt himself lauded the young artist's work and wrote to Duveneck to invite him to live and work in Boston.[52]

Duveneck's exposure in Boston occurred in two stages. After a painting of his somehow had found its way to Boston and been admired, Duveneck was invited

to exhibit paintings at the spring exhibition of the Boston Art Club in 1875 and sent five. Following their triumphant success, he exhibited a further three with the paintings dealers Doll and Richards, in August and September. Of the first group of five, three can be identified: *The Old Professor (pl. 2)*, *Portrait of Professor Ludwig Loefftz (pl. 4)*, and *Portrait of William A. Adams (fig. 19)*. There were also a head of a child and a portrait of a boy of fifteen or sixteen (which has been assumed by some to be *Whistling Boy (pl. 3)*). Of the second group of three, one was *Head of an Old Man in a Fur Cap (fig. 6)*, another *Lady with a Fan (fig. 13)*, and an unidentified portrait of a fellow student in a black hat.

Except for the *Portrait of William A. Adams*, it would appear that Duveneck showed only the paintings he had done in Munich, rather than his more realistic recent work. That the critics described these earlier paintings as strongly realistic probably reflected their strong francophile orientation and relative unfamiliarity with painting in Munich. The use of such unattractive models, for instance, while common among Munich artists, would have been seen as provocative in Paris. Another common theme in the critical response that reflected an ignorance of the context of Duveneck's Munich paintings is the comparison with the Old Masters in general and particularly Van Dyck, and surprisingly Titian and, repeatedly Velásquez. As we have seen, neither of these qualities distinguished Duveneck from his classmates, but they did set him apart from the French artists most familiar to the Bostonians. For the same reason, there was virtually no criticism of the unfinished passages in the paintings, only admiration for this quality, which also was cultivated by French artists and thus was familiar to the Boston critics. (New York critics would condemn his broad handling when they encountered it several years later.) The Boston reviewers also concurred in praising the paintings' refined color, their skillful paint handling, and the clarity and force of the artist's vision. They hailed Duveneck as a young artist showing the greatest promise, in fact, a genius.[53]

The success of his showing in Boston had brought Duveneck numerous offers of portrait commissions and the promise of a bright future there. In fact, although he did not stay, he returned to Boston in 1881 and 1889 for campaigns of portrait painting, and taught numerous Bostonians at his school in Florence. Boston was to be the single most important source of patronage for Duveneck before 1890, and he must have had a significant impact on the development of art there, although this has not been recognized in recent literature.

The Second Munich Period, 1875-1879

At this point, however, buoyed by his critical success and sales in Boston, Duveneck chose to return to Munich to lay a foundation for even greater accomplishments. He indeed did develop further during his second Munich period, which lasted from August 1875 to about October 1879, growing in technical ability, polish, and artistic vision. These years and those immediately follow-

ing saw the full flowering of his remarkable abilities.

This further development was possible because of the changes that had taken place in Munich during his nearly two-year absence. Duveneck returned to find a new circle of friends, new influences, and new stylistic currents. Most of the difference had to do with Duveneck's timing in reference to the development of Munich as a favorite place of study for Americans. Although by no means the first, Duveneck had been among the earliest arrivals. As a result, his circle of acquaintance at the beginning of his first Munich period had been almost entirely made up of Germans. A page at the back of a sketchbook from about 1871 contains figures and a list of the names of exclusively German friends.[54] Another large scrapbook from his first year is filled with clippings of newspaper woodcuts illustrating German victories in the Franco-Prussian War.[55] At this early point, he must have identified strongly with Germany. Soon American students began to arrive in significant numbers. Exceptionally gifted figures joined the growing group of Americans: J. Frank Currier (1843-1909) in January 1871; Walter Shirlaw (1838-1909) in February 1871; and William M. Chase in November 1872. By 1872 there were already twenty American students. It is perhaps significant of his changing circle of associations in Munich that, on his way back to the United States in November 1873, Duveneck wrote his first letter in English, to convey his greetings to "the boys."[56] Nonetheless, because Duveneck had risen so rapidly, achieving success while his fellow Americans were still working their way through drawing classes, the principal factors that shaped his style during the first period remained the mutual influences generated among his classmates in the Diez school and the example and precepts of Leibl and his circle. An entirely different circle of association and a new set of influences awaited the returning Duveneck. While the Diez class he knew had scattered and the Leibl circle broken up, the number of Americans had grown substantially and became sufficiently cohesive to constitute a new social community. Shirlaw, Currier, and Chase had emerged as artistic peers and, in the latter two cases, potent stylistic influences.

In essence, Duveneck's second Munich period was shaped by American influences within the German environment. There were 26 American students at the Academy when he left in late 1873, 35 when he returned, and 42 in 1878, not counting those studying outside the Academy. (The number dropped to 37 in 1879, when Duveneck took a portion of the growing number of students along with him to Italy as students in his class.) Although the increase in numbers had been gradual, a fundamental change in the degree of independence of the Americans seems to have occurred when a kind of critical mass must have been attained in the fall of 1875. This is signified by the formation of the American Artists' Club. It constituted a kind of *urbs inter urbis*, and in this respect characterized what must have been Duveneck's experience during his second Munich period. The group was an English-speaking version of Munich art student life, meeting in a neighborhood tavern, performing the *tableaux vivantes* then popular with German art students, and preparing extensive decorations for their occa-

sional banquets, as the German students did. Somewhat distinctive were their serious discussions of reproductions of Old Master paintings, a regular feature of their bi-weekly meetings.

> So decided had this tendency become that the colony of American art students in Munich grew sufficiently large to establish an art association, having stated days of meeting, at which contributed paintings were exhibited and discussed, and carefully prepared papers on art topics were read. Opinions were exchanged in this manly, earnest, sympathetic manner, and breadth and catholicity were reached in the consideration of the great question in which all were so profoundly interested. Thus were gained many of the influences which are destined to affect American art for ages to come.
>
> The writer regards as among the most improving and delightful evenings he has enjoyed those passed with some of these talented and enthusiastic art students at the table where a number regularly met to dine, at the Max Emanuel café in Munich. Dinner over, huge flagons of beer were placed before each one, and pipes were lit, whose wreaths of upward-curling smoke softened the gleam of the candles, and gave a poetic haze to the dim nooks of the hall highly congenial to the hour and the topics discussed. The leonine head of Duveneck, massively set on his broad shoulders, as from time to time behind a cloud of smoke he gave forth an opinion, lent much dignity to the scene, while the grave, thoughtful features of Shirlaw, and the dreamy, contemplative face of Chase, occasionally lit by a flash of impetuous emotion, aided by an eloquent gesture, made the occasion one of great interest. Others there were around the board whose sallies of humor or weighty expressions of opinion made an indelible impression.[57]

During his second Munich period, Duveneck was within the larger Munich art world, still in touch with Professor Diez and student friends, but his primary circle of acquaintanceship and influence was among the American colony.

Within that group, Duveneck was a senior figure of legendary abilities and verified critical success. Indeed, some of the Americans had been drawn to Munich by Duveneck's name. He easily won the respect and affection of the younger men, but the leader of the group, because of his energy, force of personality, and natural organizational abilities, would have been William M. Chase, who by this point had won a coveted place in the master class of the Academy's new director, Karl von Piloty, and had produced impressive exhibition pictures. He was now Duveneck's peer, and soon his closest associate. They went to Paris together in the spring of 1876 and spent most of a year together in Venice during 1877-78. Although in Munich they had separate studios at a distance, they often painted together and painted each other. In fact, Duveneck painted the two most ambitious paintings of his second Munich period, The Turkish Page (pl. 6) and The Cobbler's Apprentice (pl. 7), following the initiative and under the influence of Chase.

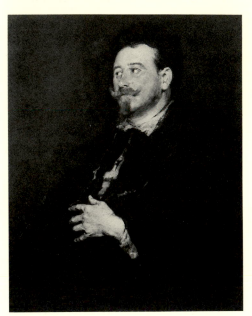

Figure 23. William M. Chase. *Portrait of the Artist Eduard Grützner*, ca. 1875, oil on canvas, 34¼ x 29 inches. Collection of Joseph Szymanski, Pasadena, California.

That Chase should have been a strong influence on the more senior Duveneck had much to do with his different background at the Academy. Although like the Diez class in its objectives of a fluent and forceful painting technique, and the conviction that the Old Masters taught its secrets, the Piloty school differed from the Diez school in its choice of Old Masters to imitate. Instead of the Dutch masters and principally the later Rembrandt, the Piloty school at this point preferred the more aggressive manner of the Spanish painters of the early Baroque period, especially Jusepe de Ribera (1588-1656). Ribera had long been Piloty's favorite artist, but the students of the 1870s were the first to fully embrace his choice, Chase more than almost any of them. His *Portrait of the Artist Eduard Grützner*, ca. 1875 *(fig. 23)*, could almost be mistaken for a work by Ribera. The emaciated model of his *The Turkish Page*, 1876 *(fig. 24)*, and the wrinkled soles of his feet recall works by the Spanish master. So Chase brought to Duveneck the challenge of a compatible period style, but one with distinct differences. Having begun his studies later than Duveneck, he was still exploring this style with his classmates, strong young talents like Hugo von Haberman (1849-1929). They reinforced the enthusiasm that Chase communicated to Duveneck, who now was in a very loose association with his own former classmates. At the same time it should be pointed out that, while Chase seems to have been the most direct influence on Duveneck's figure style after his return, he was by no means the only example of a stronger realism. The shift to a stronger lighting and more forceful realism was also a general trend throughout the Academy and among the younger artists, even in the work of Leibl from these years.

These new influences accelerated and gave final form to the shift that already was underway in the portraits Duveneck had painted in Cincinnati. At its most basic, the change Chase and others encouraged in Duveneck's earlier style was a shift along a continuum of lighting effects. Both styles aimed at a complete unity of presentation in terms of a conspicuous lighting effect. In the early works of the Diez class and works of about 1872 by members of the Leibl group, the unifying factor was a relative insufficiency of light. Position, shape, and relative warmth of color were governed by an encroaching gloom that stole from solidity and warmth. Darkness almost seemed to be an agent, an active force opposed to the solidity of form. In *Whistling Boy* and *Lady with a Fan*, for instance, only the area immediately near the figures' left eye is seen clearly. Other parts of the face itself and the body are obscured by a progressively thicker dimness that hides detail and even the clear boundaries of shapes. Parts of *Whistling Boy* are almost completely dissolved by the intervening darkness and haze. Insufficiency of light interferes with our ability to perceive almost all of the figure, although the consistency of the effect imparts a dominant impression of realism.

Instead of an unnatural dimness, an excessive brightness governs our perception in Duveneck's major paintings of his second Munich period. In *The Cobbler's Apprentice (pl. 7)*, for instance, the light is so strong that it introduces a slight confusion into our reading of the forms. It banishes shadows almost completely, except for the thin shadow under the chin and the fine lines of shadow

that cling to the edges of the forms. It also eliminates most internal modeling from the face and most parts of the body. Where there was one small point of complete clarity in the earlier figures, every part of The *Cobbler's Apprentice* is equally sharp and clear. The total impression is a consistent one, but unfamiliar to the point of being somewhat startling.

Although the objective of both styles was an impression of realism, the quality of their realism was altogether different. The obscurity of the earlier paintings lends to the figures a certain feeling of mystery, as in the *Lady with a Fan*, for instance.[58] In the male figures, this quality might better be described as poignancy or tenderness suggested by the apparent isolation of the individual and the difficulty of interpersonal communication. Ludwig Löfftz, despite his nonchalance, is presented in terms of this poignant isolation by the surrounding darkness. The whistling boy is a real boy, his distinctive features identifiable, but

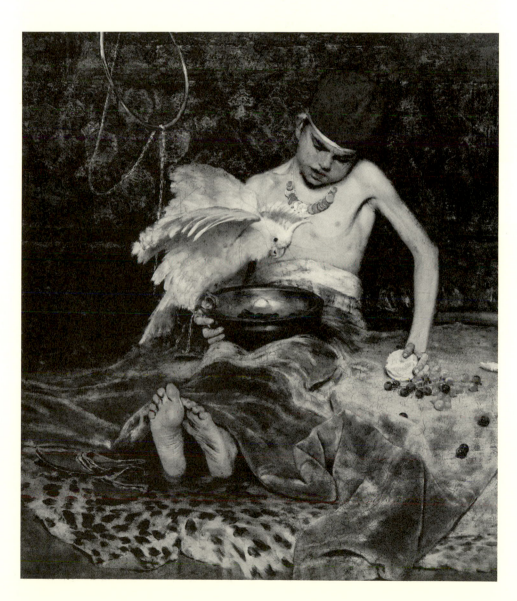

Figure 24. William Merritt Chase. *The Turkish Page*, 1876, oil on canvas, 48½ x 37⅛ inches. Cincinnati Art Museum, 1923.763.

he hardly seems tough or dangerous when engulfed by the cosmic blackness. The implied threat of this darkness is gone from the presentation of his cousin, the cobbler's apprentice. The blast of strong light eliminates any doubt or mystery, bringing the viewer abruptly up against hard and unattractive facts. Psychologically, the subject seems naked and exposed, as the crude forms of his broad cheeks and short, upturned nose are subjected to a clinical scrutiny. The quality of this realism from Duveneck's second Munich period is aggressive, brutal, and startlingly forceful.

Also sacrificed to achieving the impact of this new realism was the soft, buttery brushwork that was so attractive in the portrait of Ludwig Löfftz and so spectacular in *Whistling Boy*. Such evidence of means would have undermined the illusion central to these later paintings. But although inconspicuous, the technique of these later paintings is every bit as skillful. Modeling is achieved by the precise control of very close tonal values within the flatly lighted areas. The drawing is impeccable, the foreshortened arm and basket in *The Cobbler's Apprentice* seeming to extend into the viewer's space.

Their very degree of skill offended some critics when these paintings were exhibited in New York. *The Turkish Page (pl. 6)*, the largest and most ambitious painting of this period, drew the most extensive criticism when it was exhibited at the National Academy of Design in 1877.[59] Reviewers praised both the completeness of its illusion and the remarkable skillfulness of the sometimes summary brushwork that was able to achieve such persuasive textures and forms. But they considered this abundant display of ability to have been all that much more of a waste, since they could find in the picture no trace of poetry or ideal content. The theme of the painting is close to that of numerous works by the very popular Spanish artist Mariano Fortuny (1838-1874) who introduced as subject matter idle, often emaciated Near Eastern figures. The extremely thin child, the Near Eastern accessories, and even his mindless indolence all conformed to expectations for this kind of subject, but they were bewildering to those accustomed to the model children and pretty stories of High Victorian painting. Here was a very large, very impressive painting with no story or even action. It simply reproduced an arrangement of objects. Particularly objectionable to these critics was the fact that the artist had made no effort to alter the pale skin of the figure's upper arms and chest, which indicated that he was simply an artist's model whose customary attire was different than what he wore in the painting. This demonstrated that Duveneck had made no effort to add any element of narrative or poetry; he had only recorded the appearance of the objects before him. Moreover, he had not attempted to subordinate the accessories to the main figure, as a properly artistic painting was expected to do. As we have seen, this was a liability of the method of excessively strong lighting of the more realistic style of Duveneck's second Munich period, in which all parts of the subject were brightly lighted and fully detailed. Critics felt it mindless and inappropriate to fail to assign primary or secondary emphasis to main subjects and accessories. It seemed as though the dull brass of the ewer was painted every bit as lovingly and

exhaustively as the boy's face. It may have seemed so to those used to Victorian painting, but a comparison of Duveneck's *The Turkish Page* with Chase's side-by-side painting of the same subject *(fig. 24)* shows the extent to which Duveneck had selectively illuminated the figure of the boy, while maintaining in the peripheral areas a relative dimness absent from Chase's version. The effect is that of strong, even light, but there is some difference, upon closer examination.[60]

The strength of the critical response to Duveneck's *The Turkish Page* is a measure of its newness and its impressiveness. It was among the first of the paintings sent back by the growing group of European-trained American art students to bear witness to what could be learned abroad and to proclaim a new standard of technical mastery and sophistication. Within a few years the era of the High Victorian picture was over in this country.

Duveneck's new style was capable of great force, but was governed by an equally great degree of sensitivity. This can best be seen through a comparison of similar portraits, such as the half-length male portraits of *William Gedney Bunce (fig. 25)* and the *Portrait of Major Dillard H. Clark (fig. 26)*. How skillfully the artist has used every pictorial element at his command to shape these utterly different characterizations. Clark is presented as a romantic figure, with his dramatic upturned collar and fur hat. His body is arranged as an unstable tall pyramid. His rapid glance avoids the viewer, filling the corner of his eyelids. Bunce, in contrast, confronts the viewer squarely, like Holbein's Henry VIII. His broad frame stretches from one side of the picture to the other, powerful, but relaxed in pose. His gaze is direct, forthright, and sincere.

The artist's range of expression also extends to the touching *Woman with Forget-Me-Nots (pl. 8)*. Understood in their traditional sense, the flowers signify separation or loss. An unmistakable feeling of loneliness and sorrow is contained in the gesture of the hand held across the women's abdomen and in her distracted, inward-looking gaze and turn of her head. Her high color denotes youth, despite the severity of her black dress. Had this painting been sent to New York in place of *The Turkish Page*, the critics would have drawn a different impression of the artist's feeling for pictorial poetry and the higher emotions of what they considered true art. This sensitive and warmly human quality, so evident in his portrait characterizations, is still often overlooked today, although it is central to his art. As that most perceptive of critics, Royal Cortissoz, observed of Duveneck: "His paintings are so many affirmations of an exultant dexterity. But it is a dexterity humanized by a warmly sympathetic emotion and it is deep-rooted in the rectitude of art."[61]

Although these finished paintings represent the most significant and complex works Duveneck produced during his second period of work in Munich, numerically they are much less than half of his output. Most of his paintings were quickly executed, unfinished paintings, done on the spur of the moment and in the heat of inspiration. They occupy a special place among Duveneck's works and within the history of American art because they clearly demonstrate, openly, repeatedly, beyond a shadow of a doubt, Duveneck's place as one of the most skillful

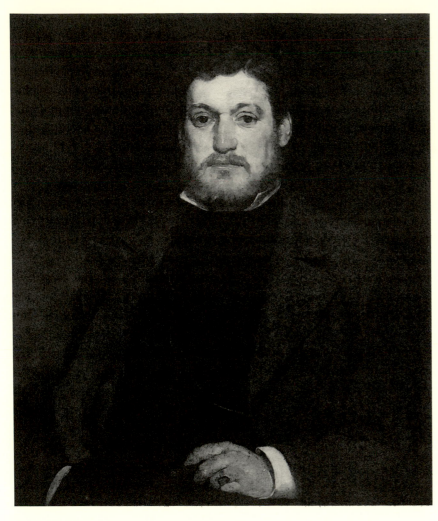

Figure 25. *William Gedney Bunce,* ca. 1878, oil on canvas, 30½ x 26 inches. National Gallery of Art, Washington, Andrew W. Mellon Collection, 1942.

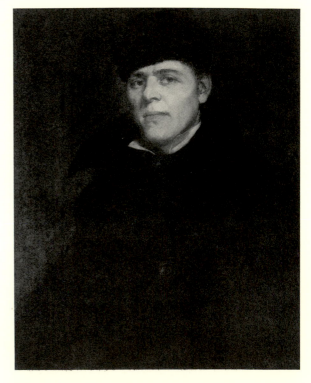

Figure 26. *Dillard H. Clark,* 1877, oil on canvas, 30¼ x 25⅜ inches. In the collection of The Corcoran Gallery of Art, Museum Purchase, Gallery Fund.

handlers of color and paint that our country has produced.

The principle of painting that Duveneck carried over from his association with the Leibl circle during the early 1870s was that of direct painting. For Duveneck the important thing was that he always paint wet-into-wet, that is to say, that he never paint over dry paint, covering one layer of paint with another so that the underneath layer partially showed through, modifying the appearance of the top layer. When applying one wet stroke upon another, the one did not lie upon the other; instead the two mixed upon the canvas, becoming one blended stroke. Better still would be if he could blend his colors and values so skillfully upon the palette that he could use relatively few brushstrokes, working quickly, laying them side by side upon the canvas in the right position and relationship that the image took shape without any stroke obscuring another. This is a feat of the greatest possible difficulty, requiring absolute clarity of observation and precision in judging exact color and value, in addition to masterly control of the brush. Yet Duveneck was so extraordinarily talented that he was able to create marvels of direct painting time after time, each an astonishingly clever and beautiful work, full of energy and brilliance. No doubt it was these paintings that prompted the often quoted remark of John S. Sargent (1856-1925), "After all's said, Frank Duveneck is the greatest talent of the brush of this generation."[62]

A few written descriptions[63] and several demonstration pieces done for his students enable us to reconstruct Duveneck's method and better appreciate his remarkable abilities. His first step was a broad drawing of the major areas of shadow, using a thin wash of brownish paint upon the white canvas. This was generally carried out quickly at the beginning of the session, but in the case of one commissioned portrait that was painted over the course of two weeks, the sketching of the shapes and shadow areas was fairly detailed and required an entire sitting.[64] This stage can be seen in the head of the bearded man in the demonstration piece, *Heads and Hands, Study (pl. 9)*. Then using a large brush and very oily paint, he laid on the flesh colors in thick, square patches of color. In spite of his breadth of handling at this stage, he was able to imitate the model quite closely, as can be seen in the head of the bald man in *Heads and Hands, Study*. In the hands on the left, the brushstrokes, to some extent, follow the forms, establishing the principal planes. Duveneck's touch in applying these patches of color was quite varied, as can be seen in *The Blacksmith (pl. 10)*, by comparing the long, broad strokes in the double chins, moustache, and nose with the shorter, more abruptly contrasting strokes that establish the broken planes of the wrinkled cheeks and areas around the eyes. Unlike some French methods that concentrated on the lights and shadows and let the middle values establish themselves, Duveneck's approach worked primarily with the middle values, in a relatively limited range that seemed complete because the values he used had been so accurately observed and so precisely recreated and kept in balance. His basic warm tan flesh color was a varying mixture of burnt sienna, red, yellow ochre and white, and perhaps even cadmium,[65] that could be mixed in the appropriate proportions of color and value for each area of the face. The great range of

colors and shades yielded by this mixture can be seen in the variety of shades that indicate different complexions, positions, and degrees of illumination in the two sets of hands. Patches of local colors of red in the cheeks, for instance, and yellow, green, and sometimes blue were applied in the proper areas and to some extent mixed in with the flesh color on the canvas.

A greater degree of smoothness and finish could be attained by brushing across several brushstrokes, partially blending them together in a modulated larger brushstroke. This process can be seen in the wrist of the foremost of the lower pair of hands in *Heads and Hands, Study*. In fact, this blending and smoothing of the original squares of paint could be taken all the way to the complete finish of the seemingly highly detailed eye and cheek in the *Portrait of Professor Ludwig Loefftz*. It must have been difficult to obtain this degree of control with the very wet paint, which would instantly blend together. As Elizabeth Boott, later to be his wife, described it "Everything is moist, he paints in a puddle, in fact. . . . The paint seems to squirm round at his bidding, in the most extraordinary manner and model itself."[66]

The painting *Man with Ruff* (pl. 11) illustrates Duveneck's bold method in beginning a head study: "Upon a slight drawing, he begins painting in thick square patches of color, laying a broad mass whenever it is possible, and imitating the model as closely as he can."[67] At the end of this process, the large and distinct early brushstrokes, that nevertheless convey a concrete and recognizable image in the painting *Man with Ruff*, are worked into the long, regular, flowing strokes that give even greater concreteness to the solid contours of *Man with Red Hair* (pl. 12).

Duveneck would try to finish most paintings through this process, all in one session, but if the results did not satisfy him the first time, he could keep the surface moist and return to work with half-dry paint. If it became dry, or if he wanted to finish the painting very finely, Duveneck would scrape down the dry paint to a very smooth surface. With the whole effect before him, keeping the surface wet, he would finish the painting part by part, working on it for as long as several weeks.

This basic method of wet-into-wet painting gives all of Duveneck's paintings of the 1870s and early 1880s a rich, fluid appearance and rich color that are highly appealing. Because a recognizable image was struck in the first large brushstrokes, the artist could decide that the painting was complete at almost any point in the process. As a result, his paintings present a range of appearances. No doubt most interesting of them are those at either extreme, the highly finished paintings such as *The Cobbler's Apprentice*, on the one hand, and those paintings that achieved success in a quick hour or so of direct painting, on the other hand. Because such triumphs of technique are so rare, this latter group quickly claims the attention of anyone getting to know the work of Duveneck. One of the finest of these is the *Portrait of John W. Alexander* (pl. 13). Later to develop into one of the country's most important stylistic innovators and portraitists, Alexander (1856-1915) was Duveneck's most promising protégé and among his closest

friends on the happy day when this brilliant portrait was rapidly executed. The method is clearly to be seen. The background and coat were broadly brushed in the thin dark wash that also indicated the dark areas of the hair, sideburns, eyebrows, and shadow by the nose, which were left to stand in the final surfaces. The strokes of paint in the face do not appear to be blended, just very carefully mixed on the palette and laid together, side by side. It would hardly seem possible to work by this method and still achieve both the smoothly joined values that convey an arresting effect of strong lighting and the fresh, clear pinks of the cheek, eyelid, and nose. What is more, despite the extreme economy of its means, it is an elegant image and a penetrating characterization.

Duveneck's work during the late 1870s shows a smooth development, without the sudden changes in style or subject matter that would indicate exposure to strong new artistic influences, but he did have exposure to contemporary art outside of Munich. Documentary evidence is so limited that it is hard to establish firmly his movements and whereabouts. He had stopped in Paris and London on his trip home to Cincinnati in November 1873.[68] He was in Paris again in April and May 1876 for a three-week stay, with the purpose of viewing the annual Salon. The American artists there held an informal reception in his honor. He became friendly with the young J. Alden Weir (1852-1919), whose work he had spotted in the Salon.[69] He returned to Munich with a new protégé, Frederic P. Vinton (1846-1911). Duveneck had commissions to paint portraits in Stuttgart that summer. He returned to a good studio in the Academy building right next to that of Professor Diez.[70] Although he was in close association with Diez, the Academy's records indicate that he was working under the supervision of Professor Georg Hiltensperger (1806-1890) for three semesters after his return, although it is hard to imagine what Duveneck learned from the aging drawing instructor. In a letter of January 7, 1877, Weir reported that Duveneck had proposed that the two of them should pass the coming summer in Venice.[71] In a letter of February 17, 1877, to John M. Donaldson,[72] Duveneck expressed discouragement with Munich and its art market and announced an intention of moving the next summer to Paris with Chase or to London. About the beginning of May 1877, Duveneck was in Innsbruck to paint a commissioned portrait of Elizabeth Blackwell. He finished it on May 19 and left for Venice.[73] According to Duveneck's later recollections,[74] Chase and Leslie Barnum (born ca. 1847) were his original companions, and Twachtman joined them later. John W. Alexander may have visited during early 1878. Elizabeth Boott wrote in a letter[75] that she had visited Duveneck in Venice. He and Chase must have stayed there about a year, living together in a three room apartment. Duveneck's major paintings from this period, *The Coming Man* (fig. 27) and *Interior of St. Mark's, Venice,* are now unlocated, and there is little else that can be definitely dated to this year to give an idea of his style then. It is one of several gaps in the known body of his work.

If Duveneck's return from Venice was after the end of July, when the Academy classes were over for the summer, he probably went directly to the town of Polling, not far from Munich, where many of his American friends were summering.

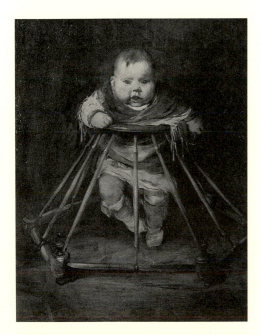

Figure 27. *The Coming Man*, 1877, oil on canvas, 36¼ x 28½ inches. Unlocated. Photograph courtesy of M. Knoedler & Co. Archives.

It was a longstanding custom of the art students in Munich to use the summer vacation for journeys and hikes into the countryside to sketch landscapes or perhaps the quaint architecture of a town like Rothenberg on the Tauber.[76] In a letter to his parents on August 19, 1871, Duveneck wrote that "in fourteen days I will get my things together and go to the country to paint studies until school begins again."[77] It is reasonable to assume that he sketched landscapes during most of his summers during his first period in Munich, but no paintings survive to bear witness to this activity, and his few remaining landscape drawings are hard to date.

The guestbook of the inn bears witness to the fact that he visited the village of Polling for the first time in 1872, in the company of his friend from the Diez class, Ernst Zimmerman. For at least a quarter century, Polling had been a spot visited and painted by Munich artists, perhaps most recently by Emil Hellrath (born 1838), who in June or July of 1872 exhibited at the Munich Kunstverein a *Landscape near Polling*.[78] According to some accounts, Duveneck went back in 1875, after his return from America, and in 1876. By 1878, the Americans were strongly established there. At this point, the dominant influence there was that of J. Frank Currier,[79] a powerful talent and a charismatic teacher who held a decade of Munich's most able American students captive by his inspired teaching. Currier was a talent of the first order, like Duveneck a master of direct painting, who, although even more forgotten today, was held in the highest esteem in the summer of 1878. Coming to Polling then, to the relatively unfamiliar genre of landscape, Duveneck must have felt the influence of Currier, who had already become a landscape specialist. Duveneck's earliest surviving landscapes are dated to this year.

Since so few such works survive from the several summers that Duveneck spent at Polling, it would not be safe to assume that he spent all of his time sketching and painting landscapes. Lacking a body of similar landscape painting by his pupils, one also cannot assume that he taught them in the field more than very occasionally.[80] Indeed, Duveneck at this point was no master of landscape in the formal sense. As fine as the observation and brushwork are in his landscape sketches, only one important finished landscape from this period is known. It would seem more likely that, like the other Americans, he painted other subjects in his studio in the village's nationalized monastery and, in the spirit of the place and season, occasionally ventured out with his materials to refresh himself in the landscape. By the early 1880s, as he worked in Venice, he developed a different level of interest in landscape and greatly increased skill in managing its formal properties.

Although traction crackle in *The Old Swimming Hole, Polling (fig. 28)* would seem to indicate otherwise in its case, all the other landscape sketches by Duveneck appear to have been painted in one session and, since they are relatively small, it would be safe to assume that they were painted before the motif. In most cases the means were economical. In *Pool at Polling, Bavaria (pl. 14)*, for instance, Duveneck's familiar brownish wash has been left exposed in most of the

Figure 28. *The Old Swimming Hole,* ca. 1878, oil on canvas, 30 x 24⅛ inches. Cincinnati Art Museum, 1919.451.

dark green areas of the water. The color is limited to essentially a range of greens, yellow in the bank, and traces of blue in the sky. On the other hand, the values range all the way from the dark forest green and black branches to the white in the sky and its reflections. The vigorous paint application, particularly in the thrusting trunks and branches and the energetic whites, recalls Currier's intensely emotional response to landscape. The same quality dominates *Beechwoods at Polling (pl. 15).* It is likewise a painting not so much about space and forms in landscape as it is about the active quality of light and the feelings it can evoke. The earth is a rich brown, and the sky is completely covered, and yet the subject is the enlivening light that dapples the ground and trunks and is glimpsed through the branches. Only the major tree trunks, with their large, regular, directional brushstrokes are convincingly solid enough to establish space around and between them. The coursing lines of paint that furrow the foreground give it, too, some solidity, but elsewhere the energetic, notational brushwork is more expressive than descriptive.

A different landscape feeling of space and solidity informs the *Landscape, Polling, Bavaria (pl. 16).* Where the others were closed by trees in the foreground or middle distance, this landscape opens up completely in a long series of gradually receding horizontal planes, with only the distant tree on the right to interrupt the smooth progression into space. The sense of solidity comes from the soft, even effect of sunshine, conveyed by the warm yellow greens in the field, the strong white of the building, the blueness at the top of the sky and reflected in the water, and the darkness of the trees against the sky. The painting's large, vague and sketchy areas in the field, and its casual lack of composition suggest that it was done in the field, unlike Duveneck's major Polling landscape, *Old Town Brook, Polling, Bavaria (pl. 17),* which has an equal degree of finish overall and a careful composition that studiously balances horizontal and vertical elements and develops a gradual progression into space. It is a highly sophisticated design that, by drawing strong horizontals across the center of the canvas and extending the vertical posts as reflections, establishes a consciousness of surface design that opposes the illusion of recession. Like most landscapes of the Munich school, it has a clouded sky and is darker than the studies, its deep tonalities closer to that of the rich figure paintings produced there. The white walls of the distant buildings and the near bank are almost the only light spots. Although relatively free, the brushwork gives an effect of finish in this highly formal landscape with its limited range of restrained color. *Old Town Brook, Polling, Bavaria* is the culmination of Duveneck's early efforts at landscape, demonstrating a knowledge and control of its formal properties and its potential for expression, in this case of a mood of alert melancholy.

During the following season back in Munich, Duveneck assumed the role of instructor for many of those with whom he had painted and enjoyed himself at Polling. To a large extent, this initial call to teaching came to Duveneck probably because of overcrowding at the Academy. The fame of Duveneck and many other successful artists trained in Munich had brought ever-increasing numbers of stu-

dents to the institution, which still waited for the completion of an adequate new academy structure. Students found it increasingly difficult to gain access to the instructors with whom they most wanted to work, a situation described by John W. Alexander in a letter to Col. E. J. Alen, written from Munich on March 24, 1878:

> I will have great difficulty getting into a painting class as they are so full, and the painters do not change as the "Antiques" do. If Benczior [sic] does not have a painting class when I have been one term in the life class I think I will go with Diez, who is one of the very best painters in the world. But it will be even more difficult to get with him than with any other on account of his reputation. Some students have been waiting three or four terms, which I won't do . . . There is even some trouble about getting into the life class.[81]

Shirlaw had left for New York in February 1877 and Chase had followed him in August 1878. With Currier remaining at Polling, Duveneck had become the outstanding senior figure to the young men in Munich, so their request for instruction came to him. Having begun a class for a small group of Americans, Duveneck proved himself to be an excellent teacher. The class grew to the point that it had to be divided into two classes, one of them for Americans and English students and the other for those who spoke other languages.[82] It was said that one of the older professors at the Academy had taken his son from there and put him in Duveneck's class.[83] Little is known about who attended these classes or how they were taught.

By July of 1879 Duveneck and his friends, among them students of his, were back in Polling for the summer. (Duveneck returned to Munich one day each week to teach a class to Miss Boott and perhaps do other things or teach additional classes.) Among his American companions that summer were John W. Alexander, John O. Anderson (born ca. 1855), an English artist, James Y. Carrington (died 1892), J. Frank Currier, Joseph DeCamp (1858-1923), Edward H. Dwight (born ca. 1856), Frederick W. Freer (1849-1930), Albert G. Reinhard (1854-1926), Louis Ritter (1854-1892), Julius Rolshoven (1858-1930), Henry M. Rosenberg (born 1858), Clagget D. Spangler (born ca. 1848), Ross Turner (1847-1915), and Theodore Wendel (1857-1932).[84]

Italy and then Boston, 1879-1882

In September Duveneck made an unexpected decision to move his class to Florence that fall, rather than to resume in Munich. Although full of art treasures and distinguished expatriates, Florence was not, at that time, thought of as a center for art study or even a place visited by artists from other countries, as, for instance, Venice was. Duveneck's decision to move there almost certainly was

prompted by the urgings of Miss Boott, who made her home there. She no doubt offered to organize the class of ladies that formed immediately upon Duveneck's arrival. He was ready for a change, and that class would assure him of the teaching income he might give up by leaving his established class in Munich. On October 5, 1879, Duveneck, John W. Alexander, and two others of "the boys", went to Florence, where they were welcomed by Miss Boott and her father. Another fifteen or so followed them later that month. The classes continued until April 1880, when most of the young men went to Venice for the summer. Some may have gone back to Munich. Duveneck had intended to begin the summer with a visit to Paris and London to see the Salon and the exhibition at the Royal Academy, but it seems he did not do so.[85] The classes resumed in Florence in October 1880 and concluded for the last time in April 1881. During that final season, Duveneck had considered moving the classes to Rome and to Paris, but in March 1881 he announced his intention to return to America in the fall.[86]

During the two years that they lasted, Duveneck's classes in Florence were a success on every count. Because his female pupils were mostly amateur artists, less is known about the large and active ladies' class. A significant part of the class were Bostonians, friends of Miss Boott. The class joined "the boys" for teas, museum visits, monotype parties, and other social occasions that brightened their long days of hard work.[87] The roll of the men's classes, on the other hand, is an impressive one, in view of the later careers of some of its members. It included mostly Americans who had studied in Munich, about half of them having been companions of Duveneck's the summer of 1879 at Polling. It is not possible to say how many of the initial class in Florence had been members of Duveneck's class in Munich the previous season. According to a list[88] furnished in later years by Charles E. Mills (1856-1956), one of its members, the Duveneck school in Florence, over the entire two-year period, was composed of the following members from Munich: John W. Alexander, John O. Anderson, Otto Bacher (1858-1923), Charles A. Corwin (1857-1938), Joseph DeCamp (1858-1923), an artist named Forbes, Charles H. Freeman (1859-1918), Oliver D. Grover (1861-1927), a Norwegian artist named Grünwald, George E. Hopkins (born 1855), Charles E. Mills, Albert G. Reinhard, Louis Ritter, Julius Rolshoven, Henry M. Rosenberg, Theodore Wendel, and Edward R. Smith (1854-1921), a sculptor. During the last winter they were joined by four students who were not from Munich: Harper Pennington (1854-1920), Julian Story (1858-1919), Ralph Curtis (1854-1922), and William Haskins, an Englishman. (Both Story and Curtis had been acquainted with Miss Boott, and may have been drawn to the class by her enthusiasm.) Four other Americans, although not in the school, were part of the group, eating at the same restaurant: Leslie Barnum, Ross Turner, John Twachtman, and Theodore Wores (1860-1939). The size of the male group varied over the two-year period, but was eventually fixed at fifteen, a number that could only be increased by the unanimous vote of the class upon a request by Duveneck himself.[89] This made it easier to turn down the many applications, avoiding placing too great a demand upon Duveneck's own time.

Besides the ladies' large studio, there were two for the young men. By the sec-

ond year, these represented separate classes. The smaller of these contained five of the more advanced students, who worked on their own paintings under Duveneck's supervision – the equivalent of the Composition Class, or master class, at the Academy in Munich. The other ten students worked in what corresponded to the Academy's class in Painting Technique. They painted from the model, mostly heads, but also full figures, working from eight-thirty in the morning until noon, and again from one until four o'clock in the afternoon. As in Munich, the students drew from the model in the evening. Duveneck would visit the class about two or three times a week, both to criticize their work and to paint demonstration pieces before them.

This demanding work schedule explains the progress made by the students and should correct the impression given by the stories that have come down to us, all accounts of adventures and colorful Bohemian life. The students were portrayed in this light already in 1886, in the novel *Indian Summer* by William Dean Howells, in which they appear as "the Inglehart Boys", a lively, sophomoric group on whom the beauties of Italy and its art are lost. Among other things, the book's description of them says, "They were a great sensation in Florence. They went everywhere and were such favorites." Thanks to Miss Boott's introduction, they had been welcomed by the large American and English colonies there. With this group and among themselves, they must have had a lively social life. In Venice their wider associations would have been primarily among the much larger group of artists there.[90]

At least partly because Duveneck was surrounded in Italy with students who had a similar background of experience with Munich styles, his own style changed very little during his first years there. While refining and perfecting it, until about 1884 Duveneck continued the dramatic, realistic style of his work of the late 1870s in Munich. Curiously, his very removal from Munich also was a factor in his continuation of this style. Had he remained there, Duveneck probably would have been influenced by the basic change in style that occurred generally in Munich soon after 1880, a shift to a light palette and an even, daylight illumination that would have made Duveneck's style seem distinctly out-of-date.

If more of the study heads and demonstration pieces were dated, it might be possible to distinguish more precisely the limited shift that did take place within Duveneck's style after his move to Italy. As it is, this large group of only approximately dated studies, such as the *Seated Nude (pl. 18)* or *Heads and Hands, Study*, could be assigned just as easily to the Munich or Italian years. However, from the few cases in which studies are dated or can be identified with Italy through costume or facial type, a few tentative generalizations can be made. In a small group of small panel paintings of about 1880, *Venetian Woman (fig. 29)*, *Study of a Woman's Head (fig. 30)*, *A Fellow Artist in Costume-Portrait of Julian Story (pl. 19)*, and *Italian Girl (pl. 20)*, for instance, the artist painted more thinly and finely in the face areas, seeking an effect of Old Master craftsmanship and tighter realism. Another group of studies datable to the early 1880s, *Guard of the Harem (pl. 21)*, *Head of a Girl (pl. 22)*, and *Still Life with Watermelon (pl. 23)*,

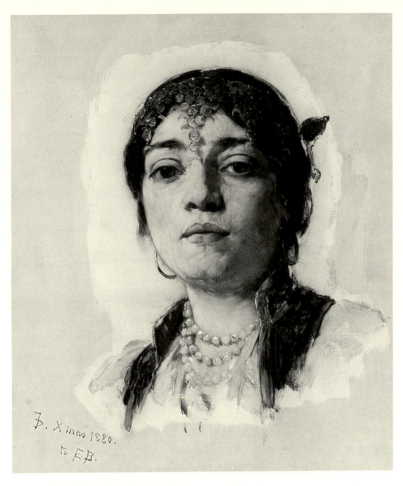

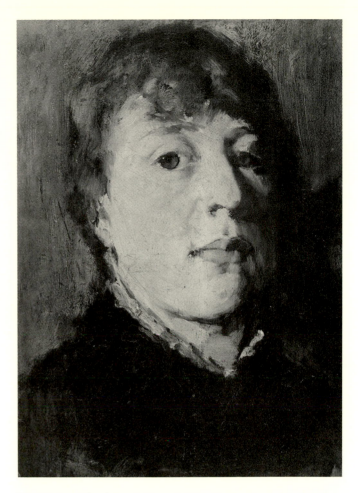

Figure 29. *Venetian Woman*, 1880, oil on panel, 13 x 10 inches. The Duveneck Family.

Figure 30. *Study of a Woman's Head*, ca. 1880, oil on panel, 13 x 8½ inches. Harvard University Art Museums (Fogg Art Museum), Purchase from the Louise E. Bettens Fund.

demonstrate an increased consciousness of the enlivening potential of color accents. How effectively the blue and amber at the neck of *Head of a Girl (pl. 22)* set off her light complexion and red lips. How suggestive of exotic richness is the spot of red headband under the pale yellow turban of the *Guard of the Harem*. *Still Life with Watermelon*, featuring the familiar Venetian treat, is justly praised for the remarkable breadth of its technique, but it is just as much a triumph of daring color combinations. The wonderfully painted flesh of the broken watermelon would not seem so vivid and real, were its pink not set off by the range of more orangish reds in the tomatoes, cloth and warm brown background, relieved by the deep green of the watermelon rind.

A new concentration on the suggestive power of color is also evident in Duveneck's very subtle Venetian marines. The sketches like *Harbor, Chioggia (fig. 31)* can be fresh and bold, with strengthening black accents, recalling the strong contrasts and vigor of Duveneck's Polling landscapes, but the large Venetian marines, such as *Scene in Venice (Private Collection)*, show a new restraint

Figure 31. *Harbor, Chioggia*, ca. 1880, oil on canvas, 19½ x 27¾ inches. Addison Gallery of American Art, Phillips Academy, Andover, Massachusetts (Candace C. Stimson Bequest).

and delicacy. The elements are few, and they are arranged in a thin band across the canvas, the mass of the ship, below the horizon, balancing that of the church, above it. Most of the surface is given to subtle variations of tints of blue and grey that evoke a sense of stillness under a slight overcast.

Subtlety and sophistication of this kind distinguish *Polling Landscape (pl. 24)*, dated 1881 and therefore painted after his two years in Italy, from the more sonorous and emphatic landscapes Duveneck had painted in Polling earlier. The grace of the circling grasses, as they sweep into the middle distance, and the balance achieved by the compact mass of bushes and trees that answer the void of the grasses, while being tied to it by the unity of their lines, demonstrate a complete mastery of landscape composition. The cloudy sky and mostly cool colors echo the suggestions of gentle melancholy explored in the Venetian marines.

This landscape, one of few clues about Duveneck's whereabouts from the summer of 1881 to the fall of 1882, suggests he must have stopped for at least a little while back in Munich and Polling. Two photographs of Duveneck, inscribed "England, 1881" *(fig. 32)*[91] confirm other suggestions that he spent part of the summer there. On November 17, 1881, Duveneck ended a visit to Cincinnati and was

on his way to Boston.[92] He was still painting portraits in Boston at the end of January and may have returned to Cincinnati in April to paint a commissioned portrait.[93] On May 24, 1882, Duveneck was reported in Covington, attending the marriage of his brother Joseph.[94] He is next reported back in Venice in November 1882.[95] Perhaps further research in Boston and Cincinnati newspapers will establish his movements during these extended blank periods.

In Boston Duveneck enjoyed his period of greatest success as a portraitist. The *Cincinnati Daily Gazette* reported: "Recent letters from Frank Duveneck report him a very busy man. He is occupying the studio of his friend, Ernest Longfellow and his Boston commissions will keep him occupied until April. As he receives $500 for a bust portrait and $1,000 for a three-quarter length, this means a golden shower."[96] Duveneck had been steadily refining his technique and expanding his artistic range and now was working at the peak of his abilities. Given the beauty and power of the superb portrait of *Mary Cabot Wheelwright* (fig. 33) and the fine portraits of the Italian period that led up to them, it is all the more regrettable that almost none of his Boston portraits are located.

Probably near the beginning of the sequence leading up to his lost Boston portraits stands the stately portrait of *Mrs. Mary E. Goddard* (fig. 34), painted in Florence, according to the account of the subject.[97] Ironically, almost all of the portraits upon which Duveneck worked hardest have been lost, and this is the earliest known formal portrait, aside from that of *Frances S. Hinkle* (fig. 18), painted in 1875. There is a similar restraint and idealization of the features of an older women, who in this case, however, is dramatized in terms of the brilliant colors of her costume, acknowledged in the portrait's alternate title, *The Crimson Gown*. The deep color of its indefinite, romantic background is used to set off both the color of the dress and the firm realism of its fabrics and lace. But there was no need for idealization when Duveneck approached the *Portrait of Miss Blood* (pl. 25), an acknowledged beauty. She was an intimate of Duveneck's in Florence, a member of the strictly limited Charcoal Club, including Duveneck, Alexander, Ritter, and Smith, which met every Monday in Florence at the homes of the four lady members.[98] A forceful illumination reveals the simple, clear forms of the figure and the features of the averted face. The figure is arranged in soft, sensuous curves, and the delicate color of the flesh is seen against the slightly astringent primrose color of the dress. The solidity of the forms under the flat lighting is remarkable. They are nowhere more real than in the left hand, with its slipped bracelet and opened fingers. A contrastingly masculine image is that of *Portrait of Francis Boott* (pl. 26), its fur collar recalling the velvet sash of senatorial office in the portraits of Titian and Tintoretto. The pose is one of great reserve and dignity, but overbright lighting endows the face with a contradictory force and intensity. The strength of this overwhelmingly bright light gives the impression of being greater than even in paintings like *The Cobbler's Apprentice*, because here it seems to flatten the forms of the head and rob them of their color, especially in the forehead.[99] The extremely clever painting of the fur serves to establish the bulk of the dark figure, enabling it to hold together with the head's

Figure 32. Photograph of Frank Duveneck, 1881, Frank Duveneck Papers, 1851-1971, Archives of American Art, Smithsonian Institution.

Figure 33. *Portrait of Mary Cabot Wheelwright*,
1882, oil on canvas, 50¾₁₆ x 33³⁄₁₆ inches. The
Brooklyn Museum, Dick S. Ramsay Fund.

Figure 34. *Mrs. Mary E. Goddard (The Crimson
Gown)*, ca. 1878, oil on canvas, 58⁹⁄₁₆ x 31⁷⁄₁₆
inches. The North Carolina Museum of Art,
Raleigh.

altogether different values. The subject was the father of Duveneck's admirer and patron, Elizabeth Boott, who had become his fiancée in 1880. No doubt he was also the cause of the breaking of the engagement in 1881 and Duveneck's departure from Florence that spring. Probably at the daughter's initiative, the portrait was exhibited in the Paris Salon of 1881.[100] Although fully a product of the Munich school, it probably would not have looked out of place there. Its dramatic lighting and the quality of its realism are not unlike the work of France's leading master of masculine portraiture, Leon Bonnat (1833-1922).

The increasing mastery of these steadily more and more impressive portraits of the Italian period promises that the portraits Duveneck painted in Boston in 1881 and 1882 were his finest achievements in portraiture and perhaps as an artist. Until these lost works are rediscovered, they will have to be imagined from what is probably an uncharacteristic example, a child's portrait. *Mary Cabot Wheelwright (fig. 33)* is seen at full length in a white dress which is a bright shape against the surrounding darkness. The figure is illuminated by the strong, flat light used in the Italian portraits although it is not so strong as to blanche the natural color of the face. The somewhat limited color tells wonderfully; the blue of the skirt and sash, repeated in the white of the dress, relieves the warmth of the floor and background. The face and costume are conceived in terms of harmonious, child-like curves.

Italy and Paris, 1882-1888: The New Style

Whether or not the Boston portraits represent the high point of Duveneck's abilities, they were the climax of the tenebrist style he had developed and refined from his first year in Munich. It is not clear exactly when Duveneck altered his approach, but almost without exception, the paintings that can be dated after his return to Venice in November 1882 are different. They are outdoor scenes, much lighter in palette and brighter in color, and they were painted using a different technique. It was almost inevitable that Duveneck would change his style, following a long separation from Munich influences, and at a time, around 1883, when an effect of diffused natural lighting had become an essential part of realism not only in France but throughout Europe, including Munich itself. Only in portraiture were the conventions of artificial studio lighting any longer acceptable.

Although the change in Duveneck's style must have pleased the Paris-trained Miss Boott, it occurred during a period of almost complete separation from her. Although he may have made trips from time to time, he spent 1883 and 1884 in Venice. In the spring of 1885 he spent some time in London,[101] and later that year opened a studio in Paris and took some kind of art instruction. Following his marriage to Miss Boott in Paris on March 25, 1886, they lived in Florence and nearby Bellosguardo, abandoning the plans Duveneck had made to return to Venice.[102] Their stay in Florence was interrupted by visits to Paris, and in November

1887 they moved to Paris for the winter. Mrs. Duveneck's unexpected death there on March 22, 1888, following a brief illness, brought to an end Duveneck's European career. By this time the change in his style, which had accelerated after 1885, was complete.

In a word, Duveneck's art after 1883 moved out-of-doors, initially into the cool, even light of a hazy day, and after 1886 into warm, direct sunlight. Except in his portraits, he worked in terms of daylight, rather than Old Master effects. At the same time, his subjects changed. Leaving behind the tough apprentices familiar in Munich painting, he now took as his subjects the pretty, lower class working women seen in the work of contemporary Venetian painters, such as Luigi Nono (1850-1918) and Alessandro Milesi (1859-1945). His other highly conventional subjects included the lighting of the shrine and tourists feeding the pigeons in St. Mark's Square. (The guard of the harem had been another of these subjects often repeated among his popular contemporaries.)

As a consequence of his change to outdoor subjects, the appearance of Duveneck's paintings and the demands upon his technique changed completely. Most basically, in these daylight scenes there was no general darkness, only the cast shadows of the individual objects. The strong light that had shone upon the figures in the Munich-style paintings had always made them appear lighter than their background. In the daylight paintings, figures and solid objects almost always appear darker than their backgrounds. They are also detached from their backgrounds, rather than partially engulfed in them, as the figures in the Munich paintings had been. As a result, they are more precisely defined, more sculptural, surrounded by more space, and set in a particular spot within a much larger volume. That space usually contains other figures or at least prominent objects which are related to the figure by perspective dimunition or perhaps superposition. The attention of the Munich paintings had been extremely concentrated, presenting a single form and unified effect with absolute control and persuasiveness; these outdoor paintings were much more diffuse and much more complicated, requiring the balancing and control of many more elements. The inspired and extremely talented manipulation of a puddle of wet paint, sufficient for a single flash of realism, was not adequate to the demands of this many-sided and much more complicated style. To meet these increased demands, Duveneck had to abandon the technique with which he had produced such brilliant and remarkably powerful results.

Study of Three Heads with Salver and Jar (pl. 27), which traditionally has been dated 1879, clearly reflects a later technique. It can be compared to another canvas full of studies, *Heads and Hands, Study* (pl. 9), which also has been dated 1879, to demonstrate the difference in technique before and after the change in Duveneck's style that occurred about 1883. The pronounced differences between them suggest that *Study of Three Heads with Salver and Jar* was executed on or after that watershed date. The basic distinction is the relative clarity of the forms in this later painting, as opposed to the relative amorphousness of those in the earlier one. Where the forms in the earlier painting had softly merged with a pal-

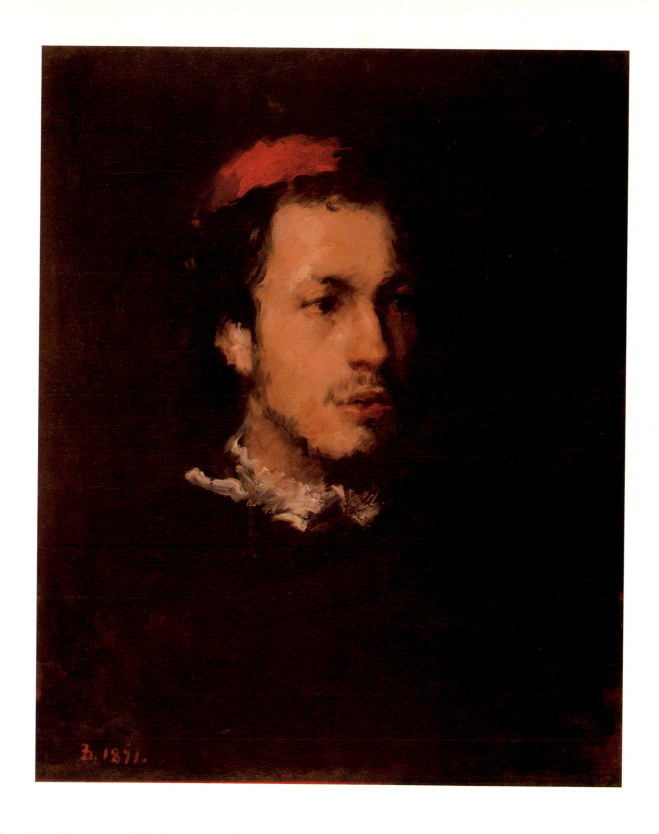

Plate 1. *Portrait of a Young Man Wearing a Red Skull Cap*, 1871, oil on canvas, 21⅞ x 18 inches. Cincinnati Art Museum, 1915.129.

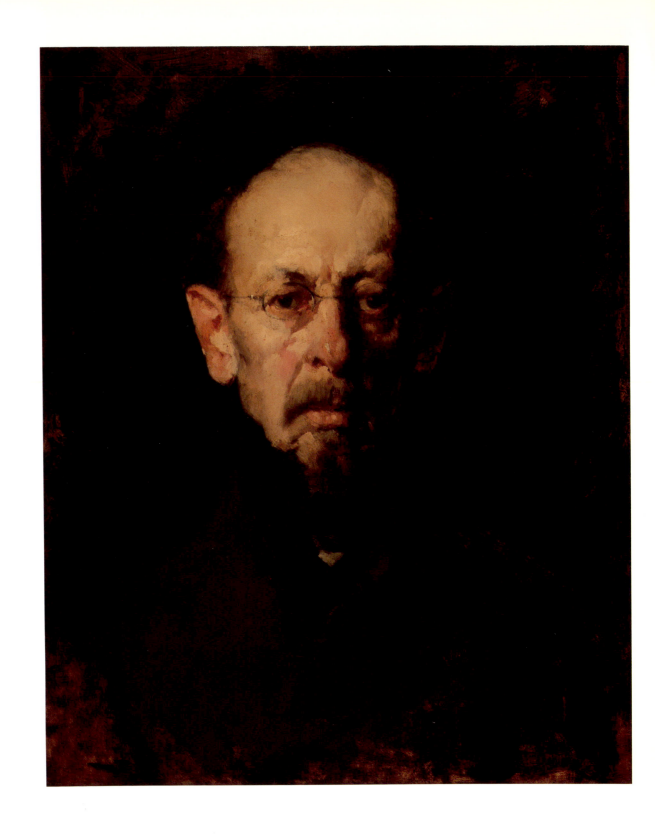

Plate 2. *The Old Professor*, 1871, oil on canvas, 24 x 19¼ inches.
Courtesy of Museum of Fine Arts, Boston, Gift of Martha B. Angell.

Plate 3. *Whistling Boy,* 1872, oil on canvas,
27⅞ x 21⅛ inches. Cincinnati Art Museum, 1904.196.

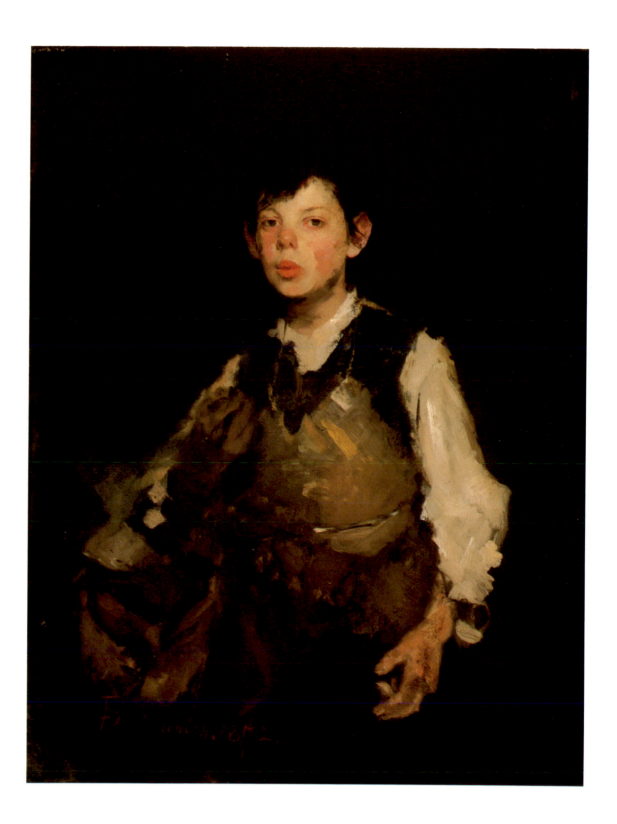

Plate 4. *Portrait of Professor Ludwig Loefftz*, ca. 1873, oil on canvas, 37^{15}/$_{16}$ x 28^{11}/$_{16}$ inches. Cincinnati Art Museum, 1917.8.

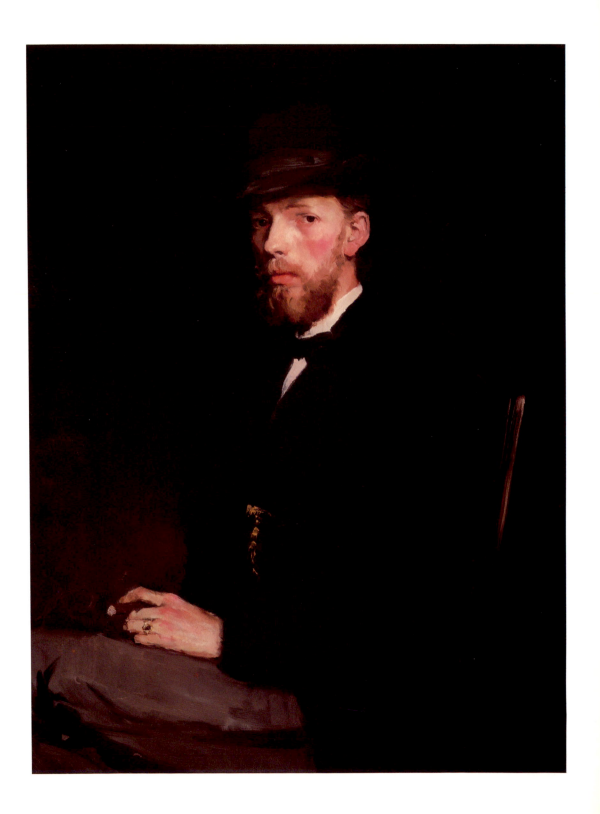

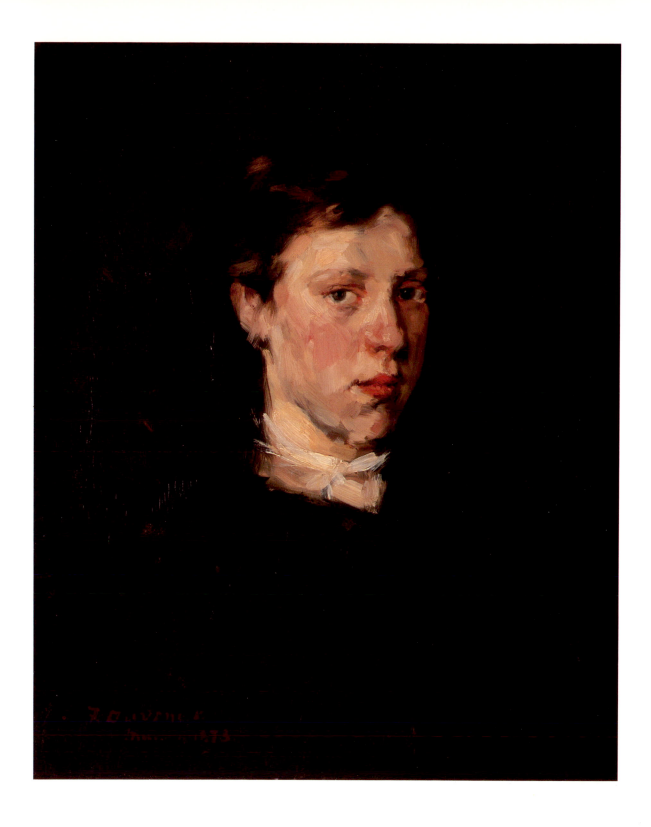

Plate 5. *Head of a Girl*, 1873, oil on canvas,
22 x 18¹⁄₁₆ inches. Cincinnati Art Museum, 1914.16.

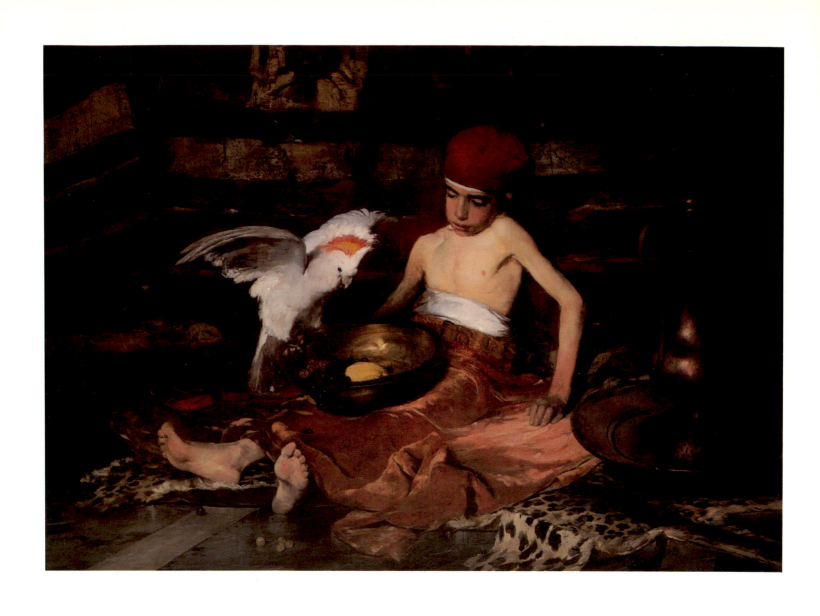

Plate 6. *The Turkish Page*, 1867, oil on canvas, 42 x 56 inches.
Courtesy of The Pennsylvania Academy of the Fine Arts, Philadelphia, Joseph E. Temple Fund.

Plate 7. *The Cobbler's Apprentice*, 1877, oil on canvas, 39½ x 27⅞ inches.
The Taft Museum, Cincinnati, Ohio, Gift of Mr. and Mrs. Charles Phelps Taft.

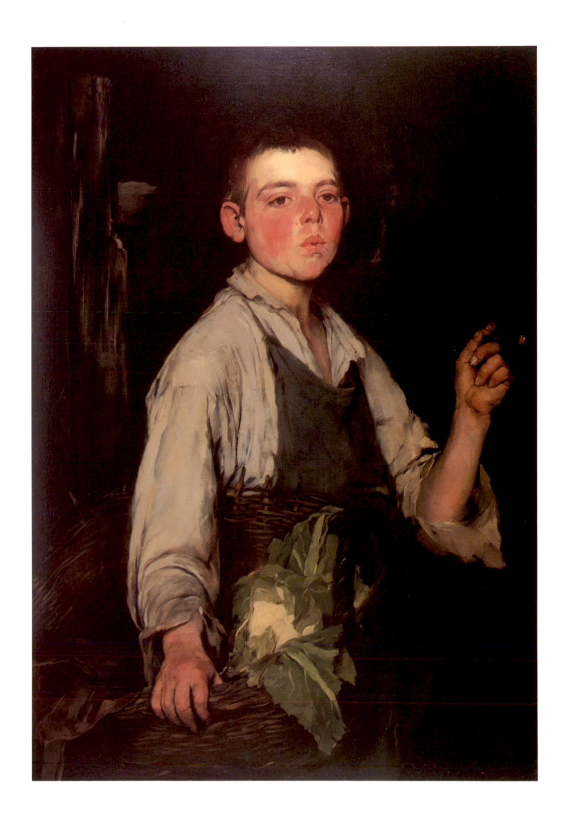

Plate 8. *Woman with Forget-Me-Nots*, ca. 1876, oil on canvas,
39¾ x 32¼ inches. Cincinnati Art Museum, 1904.195.

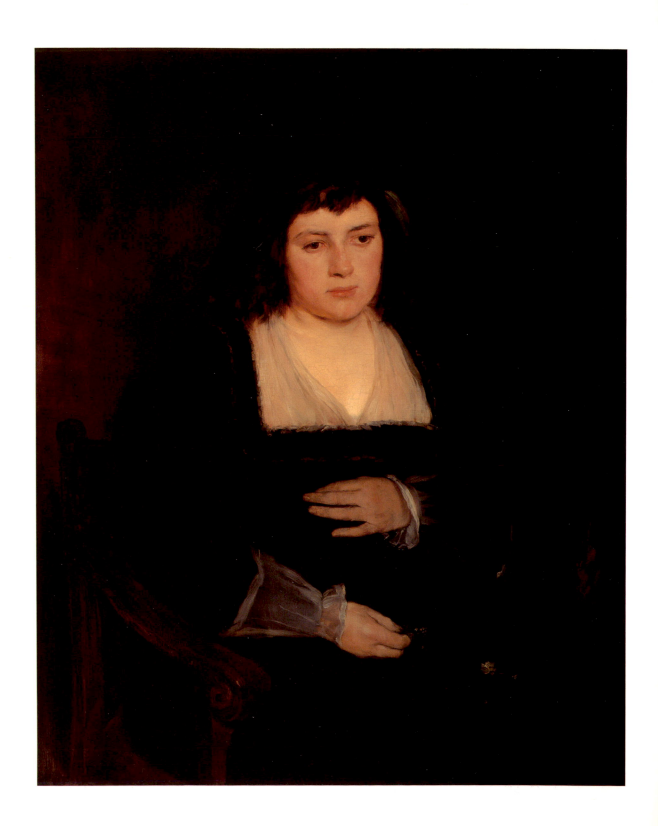

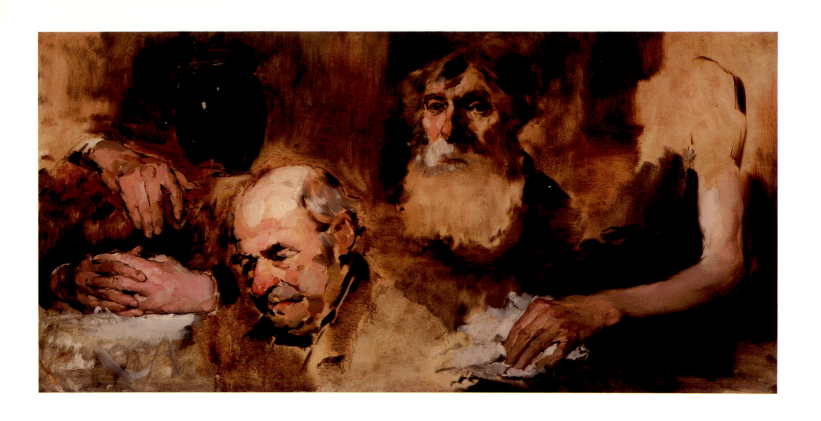

Plate 9. *Heads and Hands, Study,* 1879, oil on canvas,
23³⁄₁₆ x 46¹⁄₁₆ inches. Cincinnati Art Museum, 1915.118.

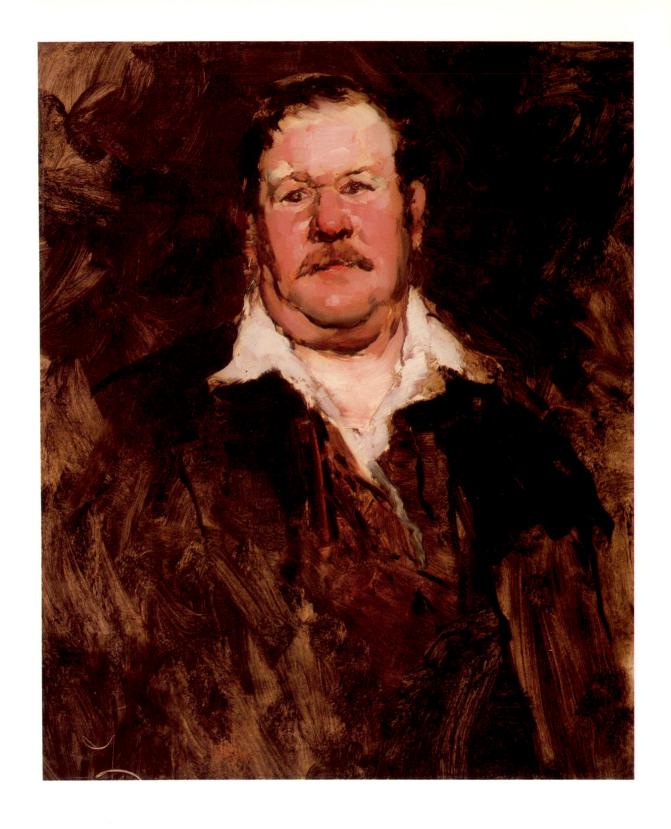

Plate 10. *The Blacksmith*, ca. 1879, oil on canvas,
27 x 21¹³⁄₁₆ inches. Cincinnati Art Museum, 1915.81.

Plate 11. *Man With Ruff,* ca. 1875, oil on canvas,
24¾ x 19¼ inches. Mr. and Mrs. David A. McCabe.

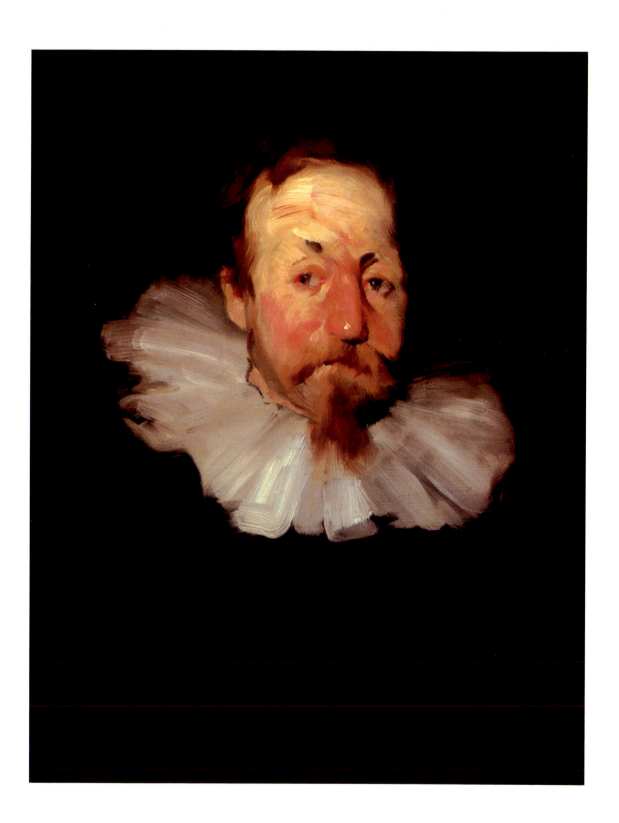

Plate 12. *Man with Red Hair,* ca. 1875, oil on canvas,
21 1/16 x 18 1/4 inches. Cincinnati Art Museum, 1899.81.

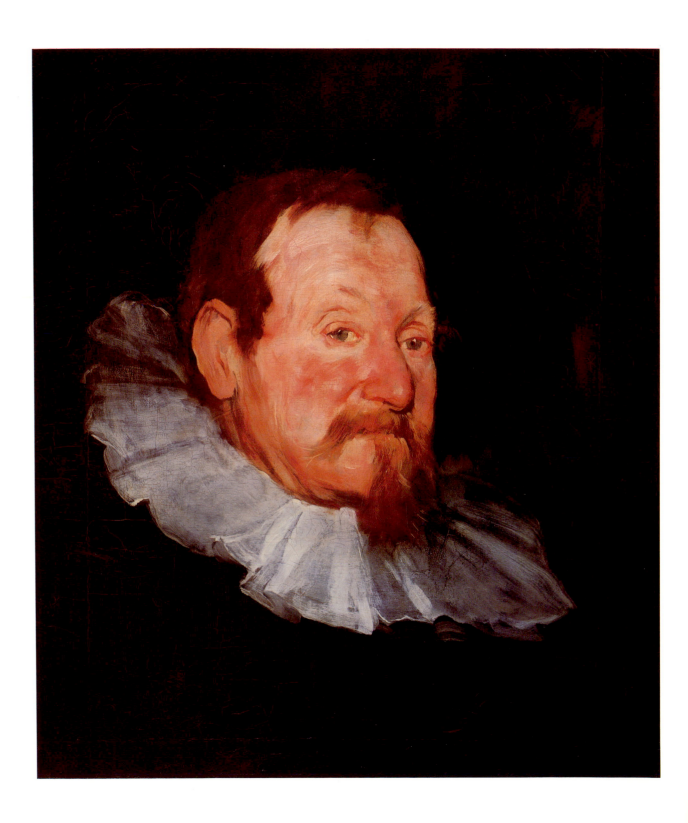

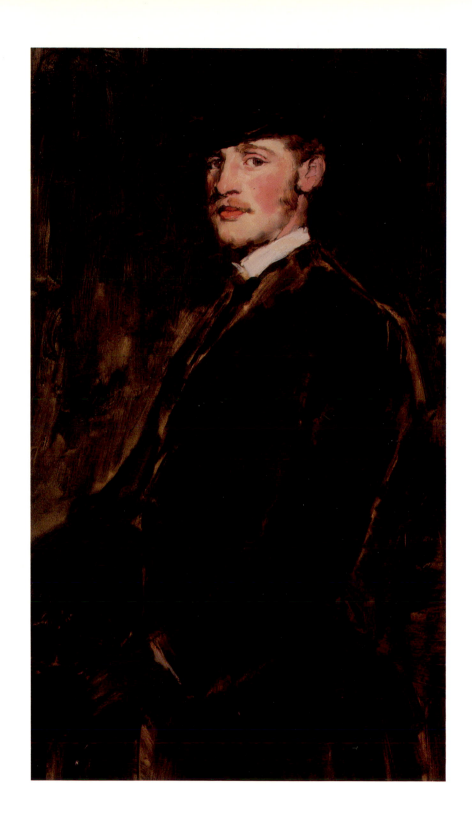

Plate 13. *Portrait of John W. Alexander,* 1879, oil on canvas,
38⅟₁₆ x 22⅟₁₆ inches. Cincinnati Art Museum, 1908.1216.

Plate 14. *Pool at Polling, Bavaria*, ca. 1880, oil on canvas,
15⁷⁄₁₆ x 21⁹⁄₁₆ inches. Cincinnati Art Museum, 1932.83.

Plate 15. *Beechwoods at Polling,* ca. 1876, oil on canvas,
45½ x 37 inches. Cincinnati Art Museum, 1915.93.

Plate 16. *Landscape, Polling, Bavaria*, ca. 1878,
oil on canvas, 23 x 31 inches. Cincinnati Art Museum, 1915.127.

Plate 17. *Old Town Brook, Polling, Bavaria,* ca. 1878, oil on canvas,
30⅞ x 49⅛ inches. Cincinnati Art Museum, 1915.145.

Plate 18. *Seated Nude*, ca. 1879, oil on canvas, 34 x 26½ inches.
Collection of Stuart Pivar, New York, at University of Virginia.

Plate 19. *Portrait of Julian Russet Story,* ca. 1880, oil on panel,
13½ x 10½ inches. Mr. and Mrs. Dale C. Bullough.

Plate 20. *Italian Girl*, ca. 1880, oil on panel,
10 x 8 inches. Private Collection.

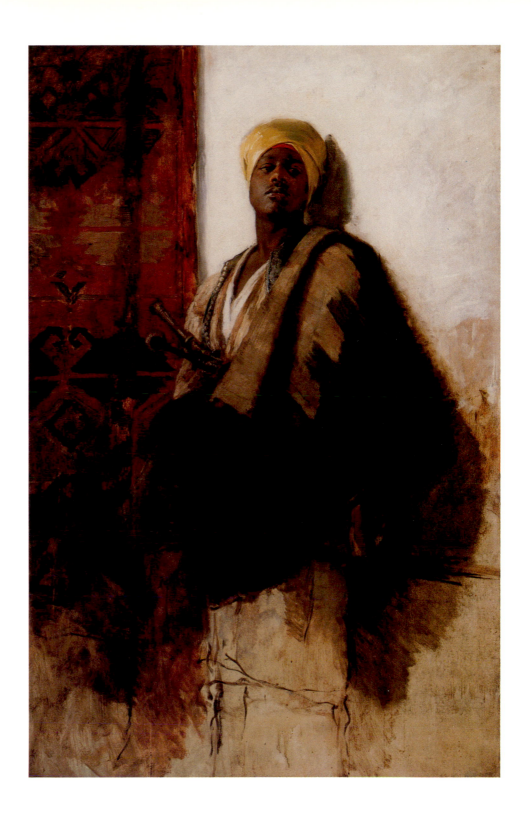

Plate 21. *Guard of the Harem*, ca. 1880, oil on canvas,
66 x 42⅟₁₆ inches. Cincinnati Art Museum, 1915.115.

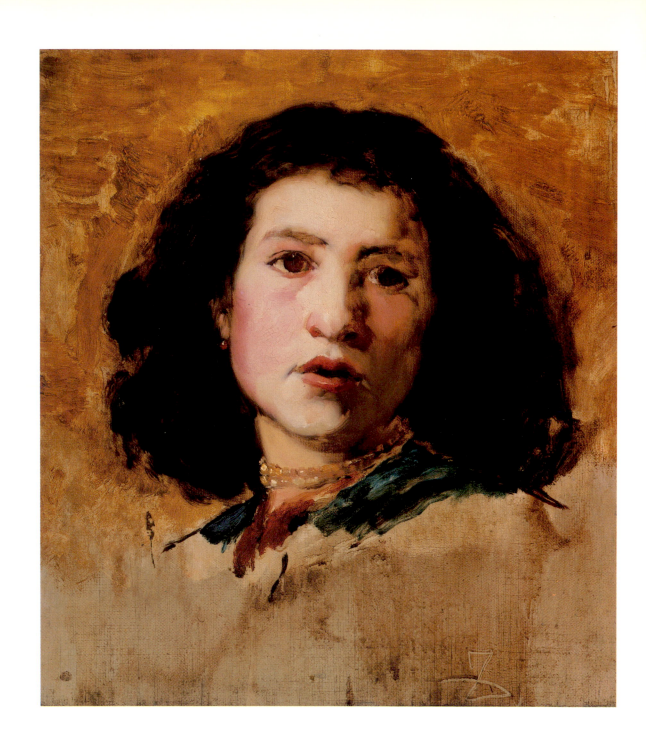

Plate 22. *Head of a Girl*, ca. 1880, oil on canvas,
16¹⁵⁄₁₆ x 15 inches. Cincinnati Art Museum, 1915.75.

Plate 23. *Still Life with Watermelon*, ca. 1878, oil on canvas,
25⅟₁₆ x 38⅟₁₆ inches. Cincinnati Art Museum, 1922.109.

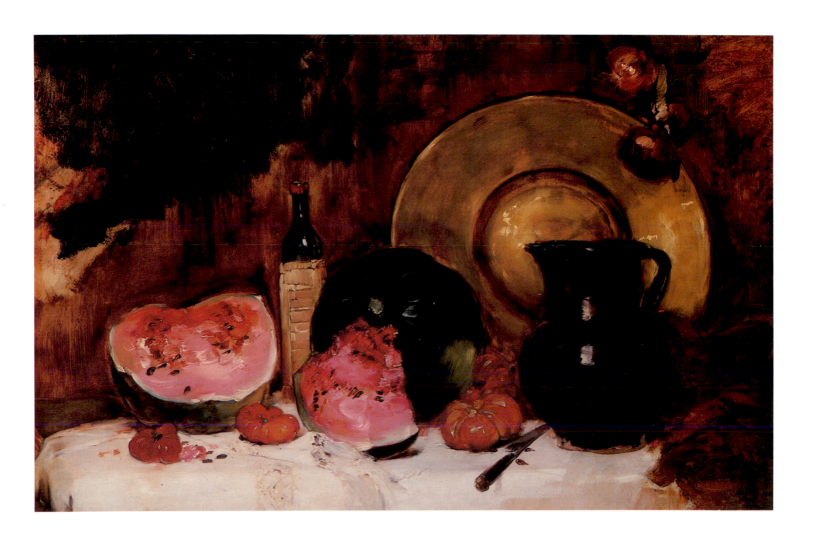

Plate 24. *Polling Landscape*, 1881, oil on canvas, 16 x 24 inches.
Indianapolis Museum of Art, Indiana, Given in memory of Charles Stayton Drake
(Gift of Mrs. Charles P. Mattingly, Indianapolis).

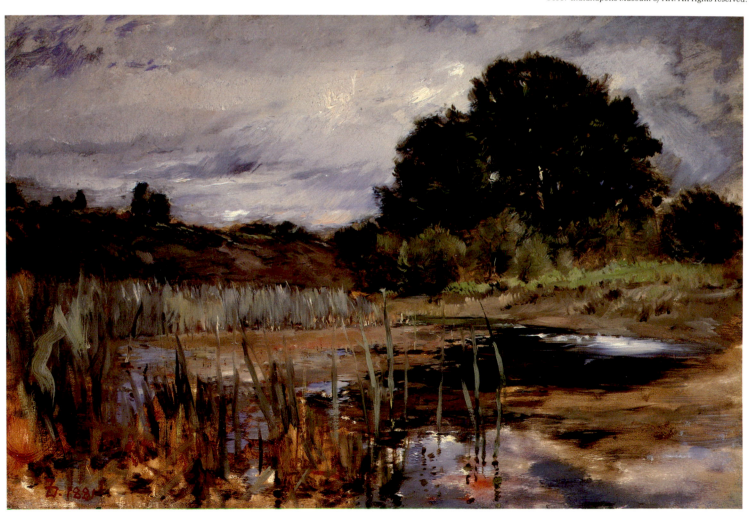

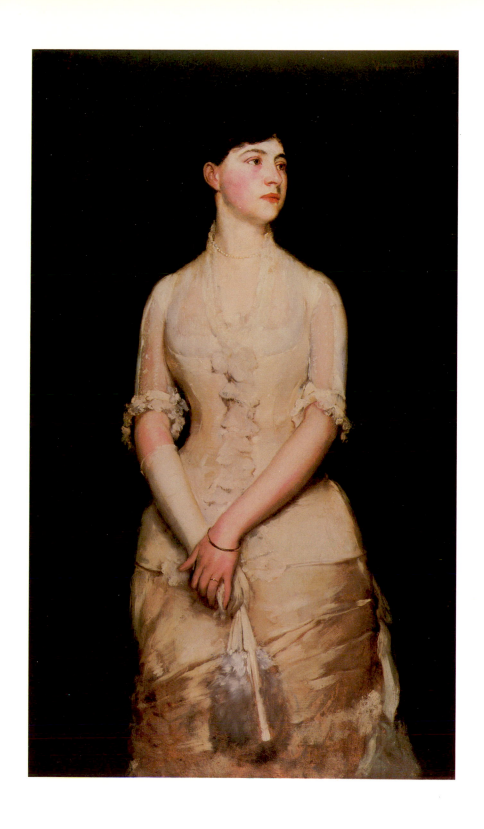

Plate 25. *Portrait of Miss Blood (Woman in a Satin Gown)*, 1880, oil on canvas,
48 x 28 inches. The Warner Collection of Gulf States Paper Corp., Tuscaloosa, Alabama.

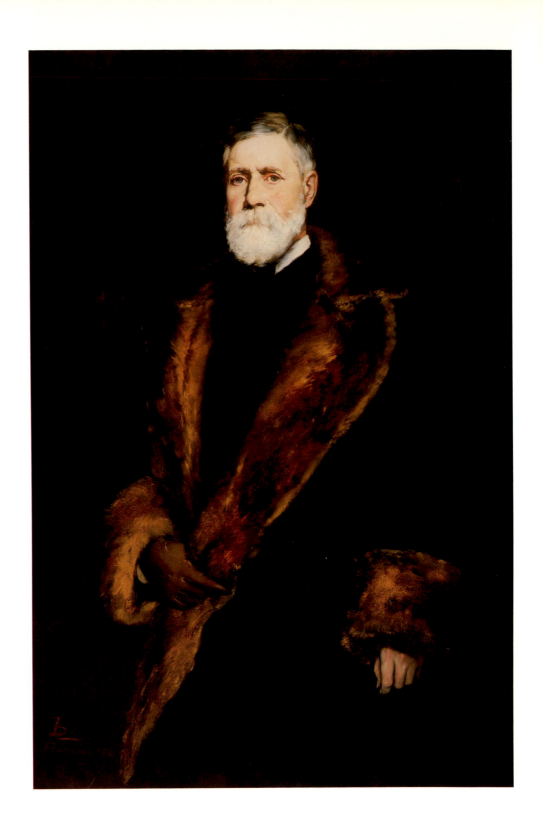

Plate 26. *Portrait of Francis Boott*, 1881, oil on canvas,
47⁹⁄₁₆ x 31¾ inches. Cincinnati Art Museum, 1969.633.

Plate 28. *Italian Courtyard*, 1886, oil on canvas,
22¼ x 33³⁄₁₆ inches. Cincinnati Art Museum, 1915.76.

Plate 29. *Italian Girl with Rake*, 1886, oil on canvas,
34 x 24¾ inches. Vose Galleries of Boston, Inc.

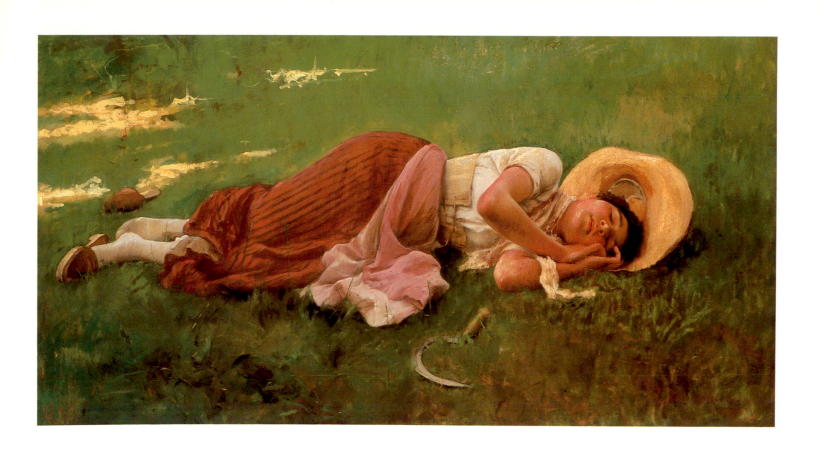

Plate 30. *Siesta*, 1887, oil on canvas,
34¾ x 64⅞ inches. Queen City Club, Cincinnati.

Plate 31. *Portrait of Elizabeth Boot Duveneck*, 1888, oil on canvas,
65⅛ x 34¾ inches. Cincinnati Art Museum, 1915.78.

Plate 32. *Portrait of Josephine Niehaus*, ca. 1885, oil on canvas,
47½ x 29¾ inches. Cincinnati Art Museum, 1965.277.

Plate 33. *Portrait of Marie Danforth Page*, ca. 1889, oil on canvas,
38 x 25¼ inches. Cincinnati Art Museum, 1915.100.

pable, surrounding darkness, the forms in the later painting are at all points distinct and always darker than the background (except for white fabrics). The comparison shows how much more "drawn" the later figures are. Where there is a sense of process and interaction with the very act of painting in the earlier work, the later figures are more planned and more methodically modeled. In the face of the right hand figure in the later canvas, the lightest area was conceived independently, as an almost abstract area with a clear shape. Moreover, in an important change from Duveneck's earlier method, this light area was applied in dry paint. Because this dry paint could not be moved around on the canvas nearly as freely and blended with neighboring areas of paint, as Duveneck's early very wet paint could be, it had to be applied exactly where it was meant to go, according to a preliminary working out of the modeling. Although the strokes of what looks like hatching in the figure's neck area is part of the process that will create a softer transition between the light area and the shadow, there can be much less blending of paint and freedom to modify with this new method. The wonderful spontaneity and dash that had imparted such life to Duveneck's best Munich period paintings had to give way to a uniform and systematic approach that could yield consistent and balanced results when applied across a larger and much more complicated composition.

In turning his original method upside down, Duveneck took a bold step forward. To many who know his work, a century later, it has seemed that he gave up more than he gained in the transaction. He became only a good painter using the new approach, whereas he had been a great one before. At the time, however, the new approach must have seemed to Duveneck to offer the means to accomplish so much more, greatly increasing his range of expression. Had he compared the clear volumes and spaces of the small still life in *Study of Three Heads with Salver and Jar* with the shallowness and spacial confusion of the otherwise wonderful *Still Life with Watermelon (pl. 23)*, would he not have felt that he was making progress? Had Duveneck been willing to content himself with a career as a portraitist, he might have enjoyed success with his old method for some years to come. It is a credit to him that he had the courage to start over again in order to find fuller expression.

The transition to the new style would have been far more difficult, perhaps even impossible, had Duveneck not been such an excellent draughtsman. This ability had enabled him to dispense with four required semesters of drawing at the Academy in only one. He had demonstrated his ability to clearly perceive difficult forms and reproduce them in works as early as *Caucasian Soldier*, 1870 *(fig. 9)*. The sculptural clarity of the head in *Portrait of Frances S. Hinkle*, 1874 *(fig. 18)* and the masterful foreshortening of the arm in *The Cobbler's Apprentice*, 1877 *(pl. 7)*, bore further witness to his talent for seeing forms. Drawing was all important to the new style, and Duveneck never fell short.

As able as he was, Duveneck may have been able to work without making preparatory drawings during his Munich period. At any rate, no drawing related to a painting of that period has survived. The more systematic method of his later Ital-

Figure 35. *Girl Washing Clothes, Venice*, ca. 1885, pencil on paper, 11 x 10 inches. Private Collection.

ian period, however, required that figure studies and composition studies be drawn as part of the process, and some of these, such as the beautiful *Girl Washing Clothes, Venice (fig. 35)* a study for *Washerwomen, Venice (fig. 36)*, have survived. It shows a mastery of anatomy, a refinement of contour, and flexibility of shading that are a great credit to the artist. These same abilities had been demonstrated in the ambitious etchings which had made for Duveneck a separate reputation during the 1880s *(fig. 37)*. Another stage in the extended process of developing the multi-figure composition of his second Italian period is shown in the oil sketches such as *Study for Washerwomen, Venice (fig. 38)* which find no equivalent among the surviving works of Duveneck's Munich period. Large and important paintings, such as the unrealized *A Reading from Tasso*, generated numerous drawings, oil sketches, and oil studies of individual figures.

Not only Duveneck's method of applying paint had changed, but his attitude toward the individual work, as well. Virtually each of his earlier paintings had been an end in itself. As far as we know, Duveneck made no preparatory studies for these works. The entire creative process leading up to the finished painting had taken place on the canvas itself, as part of the process of generating the finished (or completed) painting. The finished painting of the later Italian period, in contrast, was only the last and most important in a series of works leading up to it.

Duveneck experienced further growth in his range as an artist when in about 1886 he began to study effects of bright sunlight and to incorporate them into his figure compositions. With relatively few exceptions, his earlier landscapes and outdoor subjects had been painted under an overcast sky that gave an effect of soft, diffused light casting few strong shadows. During the period 1883-85, his palette had become much lighter, but also fairly cool. However, in the landscapes of 1886 and later, such as *Italian Courtyard (pl. 28)* and *Walls of Villa Castellani (fig. 39)*, Duveneck sought to capture the effect of strong, direct sunlight. His colors became warmer and considerably stronger, as a result.

The landscapes gain in vividness and persuasiveness as a result of the accuracy of the light effect they reproduce, but at the cost of some of the poetry of his earlier landscapes. These new landscapes concentrate upon reproducing exactly what was seen in a given moment of lighting. Their strength and interest depend upon their fidelity. Earlier landscapes, such as *Polling Landscape (pl. 24)* of just five years earlier, sought other objectives. They had been largely ideal landscapes that arranged and combined elements with some freedom for primarily expressive purposes. At their best, they have a sweep, a quality of drama, and a poignancy missing from these newer landscapes, which in contrast seem very matter-of-fact, prosaic, and limited in their emotional evocation. Only in the Gloucester landscapes of his last decades, with their exaggerated Post-Impressionist colors, would Duveneck recapture some of this expressive power.

The figure paintings that employ these newly discovered effects of strong sunlight are also much livelier and more vivid. The figure in *Italian Girl with Rake (pl. 29)* stands in a foreground shadow, but benefits from the brightness and per-

Figure 36. *Washerwomen, Venice*, 1886, oil on canvas. Unlocated. Photograph courtesy of M. Knoedler & Co. Archives.

Figure 38. *Study for Washerwomen, Venice*, ca. 1886, oil on canvas, 26 x 21 inches. The Duveneck Family.

Figure 37. *Piazza San Marco*, 1883, etching, 13⅜ x 10¾ inches. Cincinnati Art Museum, 1915.519.

Figure 39. *Walls of Villa Castellani*, ca. 1886, oil on canvas, 18 x 24 inches. The Duveneck Family.

suasiveness of the sunlit background. *Siesta (pl. 30)*, as much as anything else, for its familiar subject is so slight, is about the warmth of the sunlight that falls upon the field and sleeping worker. The figure is much more solid, the colors of her costume that much stronger, as a result of the warm light. In spite of the fact that she does not engage the viewer, she has much of the presence of the strong figures of the Munich period.

Although the pursuit of sunlight effects in his landscapes and figure paintings can be seen as an effort to achieve greater realism and force, other figures from the same years show an increased degree of idealism. By this point Duveneck was entirely free of the aggressive realism of his Munich years. Now within the orbit of Parisian styles, he sought conspicuously pretty models and a quality of charm. Moreover, a lengthy process of planning and stage-by-stage preparation separated him from the direct encounter with his models. As more stages and factors came into play, it is only to be expected that a quality of geometrical regularity and smooth transitions should emerge in his style. Such qualities distinguish his *Florentine Flower Girl (Private Collection)*, a figure whose classic perfection is somehow kept from being dull.

The same may be said for Duveneck's noble portrait of his wife *(pl. 31)*, finished shortly before her sudden death, at the most important turning point of his later life. It represents the final technique of portraiture of his European career. The portrait is quite thinly painted in fairly dry paint on a relatively coarse canvas, the nodes of which show through the paint in numerous places. There is no trace of the brush in the figure, except for very occasional textural effects in the costume. It has a feeling of finality and most delicate perfection. Actually, a great deal went into the seeming inevitability of the graceful image. It demonstrates the degree of sophistication and currency that Duveneck had achieved by this point. In the portrait Duveneck responded to the theoretical concerns widespread at the time but now identified with the Aesthetic Movement that originated in England in the early 1880s. Those participating in the movement interested themselves in the decorative possibilities of flat surfaces. They saw the painted canvas as such a surface, despite the three-dimensional illusion the artist sought to create upon it. One method of retaining the viewer's consciousness of this surface was by keeping the illusion of space as shallow as possible. This was done, as here, by establishing a flat background parallel to the picture plane and identified with the floor by the use of a common hue (or closely related hues) that covered the entire canvas, confusing the distinction between the floor and background wall. The artist then painted the figure in a similarly unified color that harmonized with the overall background color or established a slight tension with it. The other principal method for increasing consciousness of the flat picture surface was to develop in the painting a geometric structure that related to the edges of the canvas. For this purpose Duveneck established the floor line parallel to the lower edge of the canvas, just as the seam in the background curtain extends along the left side of the canvas. The upper part of the subject's arm repeats these parallel vertical lines; the lower edge of her cape and the upper edge

of her bustle are at right angles to these lines and the side of the canvas. Other elements reinforce this inconspicuous geometrical order.

The use of devices of this kind, carried further in the flatter and more highly structured *Portrait of Josephine Niehaus (pl. 32)*, demonstrates in Duveneck a degree of sophistication for which he is seldom given credit. At the point when his European career ended, he was complete master of a successful French style and in touch with the current aesthetic issues. This momentum carried him through the rest of the decade, following his return to the United States.

Elizabeth Boott Duveneck was laid to rest in Florence's Allori Cemetery late in April 1888. Duveneck and his father-in-law packed up their possessions and, closing their home in Bellosguardo, departed in August for Waltham, Massachusetts, where Mr. and Mrs. Arthur Lyman, her aunt and uncle, had offered to raise the very young Frank Boott Duveneck (1887-1985). Although deeply grieving, Frank Duveneck did not feel his career to be at an end. Late that year or in 1889, he rented a studio in Boston. For two months he taught a class assembled by a Mrs. Wadsworth, who had been a student of Duveneck's in Florence during the winter of 1880-1881. Afterwards he was busy for some time with portraits, including those of the two daughters of Mr. and Mrs. Edward Davis.[103] He also painted some portraits in Boston on subsequent visits to his son. These constitute a second group of lost Boston portraits by Duveneck. Their appearance can be anticipated from that of the lovely *Portrait of Marie Danforth Page (pl. 33)*, painted at this time.

Failing to receive such commissions after his return to Cincinnati later that year, Duveneck occupied himself in painting numerous portraits of members of his family. The portrait of his sister, Josephine Duveneck Niehaus *(pl. 32)*, probably belongs to this period, as does that of his sister Mary, known as Mollie *(fig. 40)*, whom he painted many times. During 1890, Duveneck again demonstrated his exceptional versatility by undertaking, for the first time, a large-scale sculpture as a monument to his wife *(fig. 41)*. The original bronze, installed on her grave early in 1891, was judged by all to be an accomplished and very moving sculpture. A marble replica won for Duveneck an Honorable Mention when exhibited at the Paris Salon in 1895.

Later Life, 1890-1919

During the summer of 1890, Duveneck taught landscape painting in Gloucester to a group of students from Boston.[104] That fall he began what was to be a long and fruitful relationship with the Cincinnati Art Museum and Academy, teaching a specially organized class during the winters of 1890-91 and 1891-92.[105] Although the class was a great success, he returned to Europe in the spring of 1892 to resume his painting career. Letters from Chioggia, near Venice, during the spring and summer of 1894[106] reveal that he was at work on an ambitious painting of fishermen, almost as though he were carrying forward his

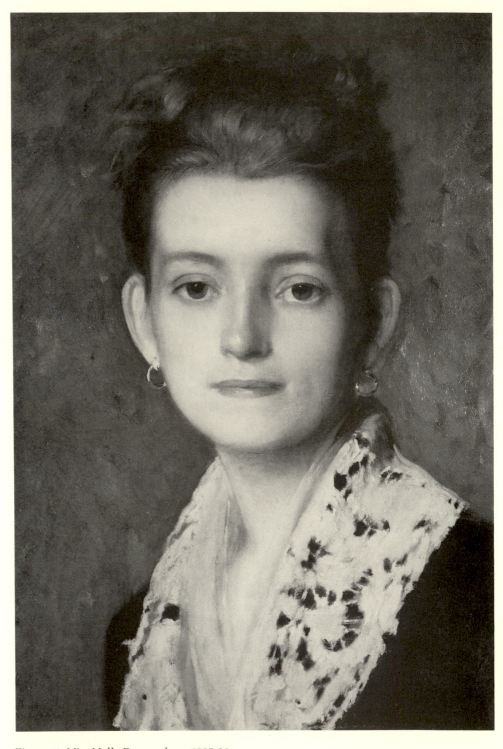

Figure 40. *Miss Molly Duveneck*, ca. 1885-90,
oil on canvas, 17 x 12⅛ inches. Collection of the
Akron Art Museum, Bequest of Edwin C. Shaw.

work where he had left off. He moved about considerably during the 1890s, principally between Paris and Florence, but also on a trip to Madrid in February 1895 for a spell of copying in the Prado. He came back to the United States several times for visits to his son and to his family in Covington, including visits in 1893 and in 1896, when he was elected the first president of the Society of Western Artists. He seems to have been much less productive during this decade, perhaps because a bequest from his wife had left him in much easier circumstances.

A turning point in his life came in 1900, when he accepted an appointment to the faculty of the Art Academy of Cincinnati. Serving that organization until his death, he taught a generation of students, a priceless legacy to the nation. His other major effort of the first decade of the century was the very large three-part mural he executed for the Cathedral in Covington as a memorial to his mother. His most important easel paintings were the richly colored Impressionist landscapes he executed during his summers in Gloucester, Massachusetts.

Content to live a quiet life in his family's very modest home in Covington, Duveneck was revered in Cincinnati, but largely forgotten in the larger circles of American art. Fortunately, he lived long enough to receive some honors in his old age. The greatest of these were the special exhibition of his work at the Panama-Pacific Exposition in San Francisco in 1915 and the special gold medal that the jury ordered to be struck in his honor. He died in Cincinnati on January 3, 1919. The collection of wonderful works that he gave and bequeathed to the Cincinnati Art Museum is his lasting memorial.

Figure 41. *Monument to Elizabeth Boott Duveneck*, 1890, bronze, 28¾ x 85⁹⁄₁₆ x 40¹³⁄₃₂ inches. Cincinnati Art Museum, 1895.146.

Notes

1. Josephine Duveneck, *Frank Duveneck, Painter-Teacher*, (San Francisco: John Howell, 1970) 56. Much of the biographical material on Duveneck is anecdotal and defies verification. Unless footnoted, all biographical information may be assumed to be taken from Josephine Duveneck's biography, which sometimes follows earlier biographical accounts.

2. *Centennial Souvenir of St. Joseph Church, Covington, Kentucky*, (n.d.) 16, 18. See also The Rev. Paul E. Ryan, *History of the Diocese of Covington, Kentucky* (Covington: The Diocese of Covington, Kentucky, 1954) 376, also 515-518.

3. Brother Nathan Cochran, O.S.B., of St. Vincent Archabbey, among other valuable assistance, has supplied me with some biographical information about Brother Cosmas Wolf from the order's archives. He was born on June 24, 1822, in Grosskissendorf, Swabia. He came to this country by 1853, when he entered the order. However, he returned to Germany in 1857 to study with the sculptor Johann Petz (1818-1880). He was on the faculty of St. Vincent's in the 1860s, before taking charge of the altar-building shop in Covington, where he worked both as a sculptor and chief designer.

4. For information about Johann Schmitt and further information about the altar-building shop at St. Joseph's, see: The Rev. Diomede Pohlkamp, "A Franciscan Artist of Kentucky," *Franciscan Studies* 7 (June, 1947): 147-170.

5. Little is known about Lamprecht. This information is taken from Ulrich Thieme and Felix Becker, *Algemeines Lexikon der Bildenden Künstler* (Leipzig: E.A. Seemann, 1927) vol. 22, p. 277.

6. Josephine Duveneck 32.

7. Josephine Duveneck 30-32, offers a translation of Brother Cosmas's letter from Newark, New Jersey, dated February 25, 1866. The original letter is in the collection of the Cincinnati Historical Society.

8. Matriculation records of the Academy of Fine Arts, Munich, in the possession of the Academy.

9. E.P. Evans, "Artists and Art Life in Munich," *The Cosmopolitan* 9.1 (May 1890) 3.

10. In the 1840s and 1850s, American artists had been drawn to study at the academy in the North German city of Düsseldorf, but following the Civil War, when Americans again left to study abroad, it was clear that Munich had far surpassed the other city, both as a place of study and as a community of successful artists. The decline of the Düsseldorf Academy was accelerated by the burning of its buildings in March 1872.

11. Published information about the Royal Academy during the period under discussion is extremely limited. The files on the affairs of the academy in the Bavarian State Archive in Munich are the only source for much important information.

12. For the founding of the Academy and its history to 1858, see Eugen von Stieler, *Die Königliche Akademie der Bildenden Künste zu München* (Munich: F. Bruckman, 1909). The second volume of this study, to cover the period 1858-1908, was never published.

13. For the various tests and rules that governed the students' progress at the Academy, see *Satzungen für die Schuler der Königlich Bayerischen Akademie der Bildenden Künste in München* (Munich: 1871).

14. Document dated May 12, 1870, File MK 14100, Bavarian State Archive, Munich.

15. For information about Wilhelm Diez, see Adolf Rosenberg, *Die Münchener Malerschule in ihrer Entwicklung seit 1871* (Leipzig, 1887) 61-62; Fritz von Ostini, "Wilhelm von Diez," *Die Kunst für Alle* 23 (November 1907): 49-62; Georg Jacob Wolf, "Wilhelm von Diez und seine Schule," *Die Kunst für Alle* 32 (October 1917): 1-18.

16. Josephine Duveneck 41-42, repeats the story that Duveneck carried his finished paintings into the Alte Pinakothek to compare them against the Old Masters.

17. Petition to the king dated July 26, 1871, file MK14110, Bavarian State Archive, Munich.

18. Document dated July 24, 1871, File MK14110, Bavarian State Archive, Munich.

19. Letter of July 22, 1871, in the possession of the estate of Frank B. Duveneck. Josephine Duveneck 39-40, offers a translation from the original German.

20. Isidor Krsnjavi, "Der Kunstunterricht an der Münchener Akademie," *Zeitschrift für Bildende Kunst* 15 (1880): 113-114.

21. Eberhard Ruhmer has written about the art theories of the Leibl circle on numerous occasions, in English in his essay "Wilhelm Leibl and his Circle" in the exhibition catalogue *Munich and American Realism in the 19th Century* (E.B. Crocker Art Gallery, Sacramento, California, 1978 9-17), and in his recent *Der Leibl-Kreis und Die Reine Malerei* (Rosenheim: Rosenheimer Verlagshaus, 1984).

22. Josephine Duveneck 38.

23. A.J.M., "Kunstvereine," *Kunst-Chronik* 8.10 (20 December 1872): col. 167-168. F.K., "Korrespondenzen," *Die Dioskuren* 17.43 (November 1872): 341.

24. Letter from Frank Duveneck to his parents dated July 22, 1871, in the possession of the estate of Frank B. Duveneck (my translation from the German).

25. Undated letter from Frank Duveneck to his parents, in the possession of the estate of Frank B. Duveneck (my translation from the German).

26. Alfred Zimmerman, "Leibl und Diez," *Das Bayerland* 32 (1928): 311-313.

27. S.R. Koehler, "Wilhelm Leibl," *The American Art Review* 1 (1880): 477-481. Koehler observed on page 478, "Among the Americans who have lately come back from Munich there is hardly a name that excites as much enthusiasm as that of this artist [Wilhelm Leibl]"

28. Norbert Heerman, *Frank Duveneck* (Boston: Houghton, Mifflin Co., 1918) 74.

29. *Catalogue of the Sixth Cincinnati Industrial Exposition* (Cincinnati: 1875) 13.

30. Letter from Frank Duveneck to his parents dated [probably February or March] 13, 1873, in the possession of the estate of Frank B. Duveneck.

31. Undated letter from Frank Duveneck to his parents in the possession of the estate of Frank B. Duveneck (my translation from the German).

32. Report of the Royal Academy of the Fine Arts to the Ministry of the Interior for Church and School Affairs, dated October 25, 1877, File MK14166, Bavarian State Archive, Munich.

33. Letter from Frank Duveneck to his parents, undated (but probably from the end of October 1872), in the possession of the estate of Frank B. Duveneck (my translation from the German). The *Cincinnati Daily Enquirer* of August 25, 1872 (p. 7, col. 2), indicated "he is now engaged on a picture which he intends to exhibit at the World's Fair next year in Vienna."

34. Letter from Frank Duveneck to his parents, dated [probably February of March] 13, 1873, in the possession of the estate of Frank B. Duveneck (my translation from the German).

35. Letter from Frank Duveneck to his parents, undated, in the possession of the estate of Frank B. Duveneck. Such a remark echoes statements also made by Leibl and his circle.

36. Josephine Duveneck 55-56. This translation apparently combines parts of two letters, one to Frank Duveneck from his stepfather dated April 1873 and the other to Frank Duveneck from his sister Katherine dated April 1, 1873. The letters are in the possession of the Cincinnati Historical Society.

37. *Cincinnati Commercial* 18 December 1873, p. 4, col. 3.

38. G. Henry Horstman, in his *Consular Reminescences* (Philadelphia: 1888) 372-377 gives a detailed account of the course of the epidemic. The cholera epidemic of 1873-1874 lasted ten months, with a death rate of only eight per thousand inhabitants. It began about the end of July, peaked in August, gradually decreased in September, and was reduced to isolated single deaths in October. There were virtually no deaths in the first part of November, and, with the arrival of cold weather, most thought they had seen the end of the epidemic. Then it suddenly increased and by the fourth of December attained a degree of virulence greater than in August. The height of the epidemic was on December 11, and the last case was reported on April 27, 1874.

39. "Mr. Duveneck proposes to spend a few months in his old home, and we hope he will make up his mind to remain here . . . ," *Cincinnati Commercial* 18 December 1873, p. 4, col. 3.

40. "On the evening previous to his departure, forty Americans at Munich tendered to him a banquet, and on the following evening his fellow students and the Professors repeated the honor. A large delegation accompanied him to Augsburg on the way to America, via Stuttgart, Karlsruhe and Paris.", *Cincinnati Enquirer* 10 December 1873, p. 8, col. 2.

41. Both letters are in the possession of the estate of Frank B. Duveneck. Josephine Duveneck offers a translation of the referenced part of the first letter on page 46.

42. George McLaughlin, "Cincinnati Artists of the Munich School," *The American Art Review* 2.1 (1881): 3.

43. Duveneck spoke of his visit to Chicago in an interview in 1916, "Frank Duveneck, Noted Painter, Gives Interview," *The Christian Science Monitor* 25 March 1916: 18. Mahonri Sharp Young, in "The Two Worlds of Frank Duveneck," *The American Art Journal* 1 (Spring, 1969) 94, indicates a trip to St. Louis. Billy Ray Booth, in *A Survey of Portraits and Figure Paintings by Frank Duveneck, 1848-1919* (Ph.D. dissertation, University of Georgia, 1970) 55-56, describes a stay in Kansas City.

44. The letter is in the possession of the Cincinnati Historical Society.

45. *Cincinnati Enquirer*, p. 8, col. 2

46. The *Enquirer* uses this form of the name, which does not appear in the Cincinnati directories. Beginning in 1874-75, they do list a "W. Thien, Fresco Decorative Artist."

47. See George McLaughlin, "Cincinnati Artists of the Munich School," *American Art Review* 2.1 (1881): 46-48.

48. For information about this class, see Bruce Weber, "Frank Duveneck and the Art Life of Cincinnati" in the exhibition catalogue *The Golden Age: Cincinnati Painting of the Nineteenth Century Represented in the Collection of the Cincinnati Art Museum* (Cincinnati Art Museum, 1979) 24.

49. Illustrated in *Frank Duveneck*, exhibition catalogue, essay by Francis W. Bilodeau (New York: Chapellier Gallery, 1972, fig. 23).

50. "A Talk with Duveneck," *Cincinnati Daily Gazette* (18 November 1881) 5.

51. *The Boston Evening Transcript* 10 August 1875, p. 5 described Duveneck as "almost discouraged by the indifference with which he was treated in Cincinnati." Other sources tell the story of Cincinnati's poor reception of his *Caucasian Soldier* (fig. 9), which was bought for a large sum in Boston. Among them are the accounts in "Duveneck's Soldier," *Cincinnati Times* 18 March 1876 and George McLaughlin, "Cincinnati Artists of the Munich School," *The American Art Review* 2.1 (1881): 3.

52. Henry C. Angell, *Records of William M. Hunt* (Boston: James R. Osgood and Co., 1881) 22-24.

53. There were a surprising number of sensitive and thoughtful reviews of Duveneck's two showings in Boston, including three by Henry James (*The Nation* 20.518 (June 3, 1875): 376-377; "On Some Pictures Lately Exhibited," *The Galaxy* 20 (July 1875): 94- 95; and *The Nation* 21 (September 9, 1875): 165-166. A review by Frederic P. Vinton also contains information about Duveneck's painting technique ("Frank Duveneck," *Boston Evening Transcript* 10 August 1875: 5). Other reviews include "Spring Exhibition of the Boston Art-Club," *The Art Journal* (N.Y.) 1 (1875): 159; and "Art," *The Atlantic Monthly* 35.212 (June 1875): 751-752.

54. Archives of American Art, Smithsonian Institution, Frank Duveneck Papers, roll 1051, frame 39.

55. Archives of American Art, Smithsonian Institution, Frank Duveneck Papers, roll 1151, frames 525-541.

56. Letter from Frank Duveneck to John M. Donaldson, dated London, November 1872, collection of the Cincinnati Art Museum.

57. S.G.W. Benjamin, "Present Tendencies of American Art," *Harper's New Monthly Magazine* 58.346 (March 1879): 484-485.

58. Frederic P. Vinton, in his review in the *Boston Evening Transcript* of August 10, 1875, wrote of this painting, "Words fail to give an adequate idea of the curious impression that this dark-eyed lady makes upon one. She seems so real, yet enveloped in mystery."

59. The longest of the reviews is typical of the spirit of most of the others: "Art," *The Atlantic Monthly* 39.235 (May 1877): 641-642.

60. In contrast to most others, Walter Montgomery, "Frank Duveneck," *American Art and Art Collections* 2 (Boston, E.W. Walker: c. 1895): 986-988, described *The Turkish Page* as a model of unity and subordination.

61. Royal Cortissoz, "The Field of Art," *Scribner's Magazine* 81 (February 1927): 221.

62. First quoted in print by Norbert Heerman in *Frank Duveneck* (Boston and New York: 1918) 1.

63. The best description of Frank Duveneck's painting method of this period is contained in a letter

from Elizabeth Boott (later Mrs. Frank Duveneck) to her friends in the Hunt class in Boston, dated Munich, June 22, 1879, and bearing different dates on other installments, in the possession of the Cincinnati Historical Society. Josephine Duveneck 77-81 quotes important passages of this long letter. The letter is available through the Archives of American Art, Smithsonian Institution, Frank Duveneck Papers, roll 1151, frames 348-373. Another, briefer account of Duveneck's painting method is contained in Frederic P. Vinton, "Frank Duveneck," *Boston Evening Transcript* 10 August 1875: 5.

64. Nancy Sahli, "A Lost Portrait? Frank Duveneck Paints Elizabeth Blackwell," *Ohio History* 85.4 (Autumn 1976): 323.

65. This palette is described by Elizabeth Boott, see note 62.

66. Elizabeth Boott, see note 62.

67. Frederic P. Vinton, see note 62.

68. Letter from Frank Duveneck to John M. Donaldson, dated London, November 1873, Collection of the Cincinnati Art Museum.

69. Dorothy Weir Young, *The Life and Letters of J. Alden Weir* (New Haven: Yale University Press, 1960) 97.

70. Letter from Frank Duveneck to his parents, dated Munich [probably May or June] 25, 1876, in the possession of the Cincinnati Historical Society. Josephine Duveneck offers a translation. Similar information is contained in a letter to his sister Katherine, dated Munich, April 17, 1876 (shortly before his trip to Paris), Archives of American Art, Smithsonian Institution, Frank Duveneck Papers, roll 1150, frames 57-59.

71. Dorothy Weir Young 177.

72. Collection of the Archives of American Art, Smithsonian Institution, John M. Donaldson Papers, roll D160, frame 499.

73. Nancy Sahli 324.

74. Frank Duveneck, "Reminiscences for Mrs. Chase to Use in Biography of Mr. Chase," Typescript, Archives of the Cincinnati Art Museum.

75. Josephine Duveneck 75-76.

76. For an account of such a summer sketching excursion, see Toby E. Rosenthal, *Erinnerungen eines Malers* (Munich, 1927) esp. 44-51. An English translation is available in William M. Kramer and Norton B. Stern, *San Francisco's Artist, Toby E. Rosenthal* (Northridge, California: Santa Susana Press, 1978) 177-183.

77. The letter is in the possession of the estate of Frank B. Duveneck (my translation).

78. *Die Dioskuren* 18.27 (7 July 1872): 213.

79. The standard study of Currier remains: Nelson C. White, *The Life and Art of J. Frank Currier* (Cambridge, Massachusetts: The Riverside Press, 1936).

80. Nevertheless, as William H. Gerdts has pointed out in "The Studio of Nature," *Art and Antiques* (May 1984): 54-56, these outdoor painting sessions must have made an important impression on the group that summer, since so many of them went on to lead classes in *plein air* painting after their return to the United States. Gerdts discusses this point further in his essay "The Teaching of Painting Out-Of-Doors in America in the Late Nineteenth Century" in *In Nature's Ways: American Landscape Painting of the Late Nineteenth Century*. (Norton Gallery of Art, West Palm Beach, Florida, 1987 30-31). It should be noted that Currier seems to have done more informal outdoor teaching at Polling than Duveneck.

81. Archives of American Art, Smithsonian Institution, John W. Alexander Papers, roll 1728, frames 56-57. (This is a typed copy of the letter.)

82. "Frank Duveneck, Noted Painter, Gives Interview," *The Christian Science Monitor* 15 March 1916: 18.

83. Letter from Elizabeth Boott to her friends in the Hunt class in Boston, dated June 22, 1879, collection of the Cincinnati Historical Society. See note 62.

84. These names are given in a drawing entitled *The American Club, Polling, Summer 79* by John W. Alexander, in the possession of the author.

85. In the collection of the Archives of American Art, Smithsonian Institution, Frank Duveneck Papers, roll 1151, is an undated letter written by Charles Mills to Josephine Duveneck, quoting from his letters written from 1879 to 1883, when he was one of the Duveneck boys and providing other important information about the classes. See the quotation from his letters of October 5, October 16, and October 27, 1879, and April 2, 1880. Other insights into this period are contained in the letters of John White Alexander, Archives of American Art, Smithsonian Institution, John White Alexander Papers, roll 1728.

86. Quotations from Charles Mills letters of December 26, 1880; February 13, 1881; and March 27, 1881, contained in the undated letter to Josephine Duveneck, Archives of American Art, Smithsonian Institution, Frank Duveneck Papers, roll 1151.

87. Letter from Mrs. Wadsworth to Frank Boott Duveneck, Archives of American Art, Smithsonian Institution, Frank Duveneck Papers, roll 1150.

88. The list is contained in the undated later to Josephine Duveneck, Archives of American Art, Smithsonian Institution, Frank Duveneck Papers, roll 1151.

89. Undated letter from Charles Mills to Josephine Duveneck, quoting from his letter to his father dated Florence, December 13, 1880, Archives of American Art, Smithsonian Institution, Frank Duveneck Papers, roll 1151. "Cincinnati Artists Abroad," in the Cincinnati Commercial of May 7, 1881, mentions that Duveneck then had a class of 18 students.

90. It is not clear with whom Duveneck associated in Venice and to what extent. According to Charles Merrill Mount (John Singer Sargent, New York, 1955, 67-68), Duveneck met Sargent in Venice, but we do not know how well they knew each other. One would think that the American and English artists would have been in touch with one another and that Duveneck would have known at least some of the German and Austrian artists there.

91. Archives of American Art, Smithsonian Institution, Frank Duveneck Papers, roll 927, frames 1043 and 1045.

92. "A Talk with Duveneck," Cincinnati Daily Gazette 18 November 1881: 5.

93. "Some Art Notes," Cincinnati Daily Gazette 28 January 1882: 6.

94. Daily Commonwealth (Covington, Kentucky) 24 May 1882: 2.

95. Letters from Charles Mills dated November 6, 1882, as excerpted in an undated letter to Josephine Duveneck, Archives of American Art, Smithsonian Institution, Frank Duveneck Papers, roll 1151.

96. Cincinnati Daily Gazette 28 January 1882.

97. Statement of Mary B. Goddard Williams, dated January 2, 1923, in the curatorial files of the North Carolina Museum of Art.

98. Letter from John White Alexander to Mrs. E.J. Allen, dated Florence, December 28, 1879, Archives of American Art, Smithsonian Institution, John White Alexander Papers, roll 1728, frame 271.

99. The evidence of reworking the forehead, so very unusual in the work of Duveneck, suggests that this whitest flesh area was a late adjustment, intensifying an earlier effect.

100. Presumably it was the Portrait de M.B. . . . listed as 833 in the catalogue of the Paris Salon of 1881.

101. Letter of November 9, 1919, from Elizabeth Pennell to Josephine Duveneck, Collection of the Cincinnati Historical Society.

102. A letter of July 4, 1886, from Otto Bacher mentions that Bacher and friends would be in the apartment in the Palazzo Contarini that Duveneck had taken and would not be using. See also the letter of October 10, 1886. Both are quoted in William W. Andrew, Otto H. Bacher (Madison, Wisconsin: Education Industries, Inc., 1973) n. pag.

103. Letter from Mrs. Wadsworth to Frank Boott Duveneck, Archives of American Art, Smithsonian Institution, Frank Duveneck Papers, roll 1150.

104. William H. Gerdts, "John Twachtman and the Artistic Colony in Gloucester at the Turn of the Century" in Twachtman in Gloucester: His Last Years, 1900-1902. (New York: Universe/Ira Spanierman Gallery, 1987) 29.

105. For an outline of Duveneck's later teaching career, see Bruce Weber, "Frank Duveneck and the Art Life of Cincinnati, 1865-1900," in *The Golden Age: Cincinnati Painters of the Nineteenth Century Represented in the Cincinnati Art Museum* (Cincinnati Art Museum, 1979) 29-30. There are numerous accounts of Duveneck as a teacher and tributes to his inspiring instruction.

106. Quoted by Josephine Duveneck 131-132.

Selected Bibliography

Arbiter, Petronius. "Frank Duveneck." *The Art World & Arts & Decoration* 10 (November 1918): 17-23.

Ashberry, John. "The Indian Summer of Frank Duveneck." *Art News* 71 (April 1872): 27-29, 69-71.

Booth, Billy Ray. *A Survey of Portraits and Figure Paintings by Frank Duveneck, 1848-1919.* Ph.D. dissertation, University of Georgia, 1970. (Ann Arbor, Michigan: University Microfilms 1971).

Cary, Elizabeth Luther. "Frank Duveneck's Etchings." *Art in America* 13 (August 1925): 274-276.

Cortissoz, Royal. "The Field of Art." *Scribner's Magazine* 81.16 (February 1927): 216-224.

Duveneck, Frank. (Interview) "Frank Duveneck, Noted Painter, Gives Interview." *The Christian Science Monitor* 25 March 1916: 18.

_____. (Interview) "A Talk with Duveneck." *Cincinnati Daily Gazette* 18 November 1881: 5.

_____. (Interview) "With Duveneck, An Afternoon in the Famous Artist's Studio." *Cincinnati Times Star* 28 October 1890: 8.

_____. (Papers) Cincinnati Historical Society, Cincinnati, Ohio.

_____. (Papers) Archives of American Art, Smithsonian Institution.

_____. "Reminiscences for Mrs. Chase to Use in Biography of Mr. Chase." (typescript) Archives of the Cincinnati Art Museum.

Duveneck, Josephine W., *Frank Duveneck: Painter-Teacher.* San Francisco, California: John Howell, 1970.

Exhibition of the Work of Frank Duveneck. Cincinnati: Cincinnati Art Museum, 1936.

Frank Duveneck, exhibition catalogue, essay by Francis W. Bilodeau. New York: Chapellier Gallery, 1972.

Freund, Frank E. Washburn. "A Great American Painter." *The Sketch Book Magazine* 6.4 (February 1929): 40-44.

_____. "The Problem of Frank Duveneck." *International Studio* 85.352 (September 1926): 39-45, 96, 100.

The Golden Age: Cincinnati Painters of the Nineteenth Century Represented in the Cincinnati Art Museum. Essays by Denny Carter, Bruce Weber, et al. Cincinnati: Cincinnati Art Museum, 1979.

Heerman, Norbert. *Frank Duveneck.* Boston: Houghton Mifflin Company, 1918.

_____. *Paintings by Frank Duveneck 1848-1919,* exhibition catalogue. New York: Whitney Museum of American Art, 1938.

Loughmiller, Henry C. "I Studied with Duveneck." *American Artist* 28 (March 1965): 40-45, 67-71.

Lowe, Jeannette. "The Whitney Memorializes Duveneck." *Art News* 36 (23 April 1938): 9, 19.

Lucas, E.V. "Blakelock and Duveneck." *The Ladies' Home Journal* 44.2 (February 1927): 28, 185.

McCann, Clarence David, Jr. *The Ripening*

of American Art: Duveneck and Chase, exhibition catalogue. Mobile, Alabama: The Fine Arts Museum of the South at Mobile, 1979.

McChesney, Mrs. H.V. "Some Kentucky Painters." *Kentucky Progress Magazine* 6 (Spring 1934): 123-125.

McLaughlin, George. "Cincinnati Artists of the Munich School." *The American Art Review* 2.1 (November 1880): 1-4.

Meakin, L.H. "Duveneck, a Teacher of Artists." *Arts and Decoration* 1 (July 1911): 382-384.

Montgomery, Walter. "Frank Duveneck." *American Art and American Art Collections,* vol. 2. Boston: E.W. Walker, c. 1890.

Neuhaus, Robert. *Bildnismalerei des Leibl-Kreises.* Marburg, Germany: Verlag Des Kunstgeschichtlichen Seminars, 1953.

————. "Der Idealismus von Frank Duveneck." *Festscrift Richard Hamann.* Burg: August Hopfer Verlag, 1939, 89-93.

Poole, Emily. "Catalogue of the Etchings of Frank Duveneck." *The Print Collector's Quarterly* 25 (December 1938): 446- 463.

————. "Etchings of Frank Duveneck." *The Print Collector's Quarterly* 25.3 (October 1938): 313-331.

Sahli, Nancy. "A Lost Portrait? Frank Duveneck Paints Elizabeth Blackwell." *Ohio History* 85.4 (Autumn 1976): 320-325.

Seaton-Schmidt, Anna. "Frank Duveneck: Artist and Teacher." *Art and Progress* 6.11 (September 1915): 387-394.

Sherman, Frederic Fairchild. "Frank Duveneck." *Art in America* 16 (February 1928): 91-98.

Smith, Jacob Getlar. "Frank Duveneck-Missionary." *American Artist* 21 (April 1957): 36-41, 66-67.

Thomson, D. Croal. "Frank Duveneck." *Connoisseur* 61.241 (September 1921): 3-10.

Walton, William. "Two Schools of Art: Frank Duveneck, Frederick C. Frieseke." *Scribner's Magazine* 43.69 (November 1915): 643-645.

Young, Mahonri Sharp. "An American Realist." *Apollo* 96.126 (n.s.) (August 1972): 163-164.

————. "The Two Worlds of Frank Duveneck." *The American Art Journal* 1.1 (Spring 1969): 92-103.

————. "Duveneck and Henry James: A Study in Contrasts." *Apollo* 92.103 (n.s.) (September 1970): 210-217.

Checklist

Caucasian Soldier, 1870, oil on canvas, 50¼ x 41¼ inches. Museum of Fine Arts, Boston.

Portrait of a Young Man Wearing a Red Skull Cap, 1871, oil on canvas, 21⅞ x 18 inches. Cincinnati Art Museum, 1915.129.

The Old Professor, 1871, oil on canvas, 24 x 19¼ inches. Courtesy of Museum of Fine Arts, Boston; Gift of Martha B. Angell.

Head of a Girl, ca. 1872, oil on canvas, 21⅛ x 17½ inches. In the collection of The Corcoran Gallery of Art; Museum Purchase, Gallery Fund.

Whistling Boy, 1872, oil on canvas, 27⅞ x 21⅛ inches. Cincinnati Art Museum, 1904.196.

Lady With a Fan, 1873, oil on canvas, 42¾ x 32¼ inches. Lent by the Metropolitan Museum of Art; Gift of the Charles F. Williams Family, 1966.

Portrait of Professor Ludwig Loefftz, 1873, oil on canvas, 37¹⁵⁄₁₆ x 28¹¹⁄₁₆ inches. Cincinnati Art Museum, 1917.8.

Head of a Girl, 1873, oil on canvas, 22 x 18¹⁄₁₆ inches. Cincinnati Art Museum, 1914.16.

William Adams, 1874, oil on canvas, 60⅛ x 48¼ inches. Milwaukee Art Museum Collection; Gift of Mr. and Mrs. Myron Laskin, Mr. and Mrs. George G. Schneider and Dr. and Mrs. Arthur J. Patek, Jr. in memory of Dr. and Mrs. Arthur J. Patek.

Portrait of Henry L. Fry, ca. 1874, oil on canvas, 19¹¹⁄₁₆ x 16³⁄₁₆ inches. Cincinnati Art Museum, 1907.193.

Portrait of Squire Duveneck, 1875, oil on canvas, 30 x 25 inches. Rosenberger Gallery, Centerport, New York.

Man with Red Hair, ca. 1875, oil on canvas, 21¹⁄₁₆ x 18¼ inches. Cincinnati Art Museum, 1899.81.

Portrait of George von Hoesslin, ca. 1875, oil on canvas, 16 x 13¾ inches. The Detroit Institute of Arts; City of Detroit Purchase.

The Turkish Page, 1876, oil on canvas, 42 x 56 inches. Courtesy of The Pennsylvania Academy of the Fine Arts, Philadelphia; Joseph E. Temple Fund.

Woman with Forget-Me-Nots, ca. 1876, oil on canvas, 39¾ x 32¼ inches. Cincinnati Art Museum, 1904.195.

Beechwoods at Polling, ca. 1876, oil on canvas, 45½ x 37 inches. Cincinnati Art Museum, 1915.93.

The Cobbler's Apprentice, 1877, oil on canvas, 39½ x 27⅞ inches. The Taft Museum, Cincinnati, Ohio; Gift of Mr. and Mrs. Charles Phelps Taft.

Self-Portrait, ca. 1877, oil on canvas, 29¹⁄₁₆ x 23¹¹⁄₁₆ inches. Cincinnati Art Museum, 1915.122.

He Lives By His Wits, 1878, oil on canvas, 44¾ x 28 inches. Private Collection.

Old Town Brook Polling, Bavaria, ca. 1878, oil on canvas, 30⅞ x 49⅛ inches. Cincinnati Art Museum, 1915.145.

Still Life with Watermelon, ca. 1878, oil on canvas, 25¹⁄₁₆ x 38¹⁄₁₆ inches. Cincinnati Art Museum, 1922.109.

Profile of a Girl with Hat, 1878, oil on canvas, 11⅛ x 12¹¹⁄₁₆ inches. Cincinnati Art Museum, 1915.109.

William Gedney Bunce, ca. 1878, oil on canvas, 30½ x 26 inches. National Gallery of Art, Washington, Andrew W. Mellon 1942.8.4

Self-Portrait, ca. 1878, oil on canvas, 19⅝ x 15⅝ inches. Indianapolis Museum of Art; Gift of Mrs. John N. Carey.

Mrs. Mary E. Goddard (The Crimson Gown), ca. 1878, oil on canvas, 58⁹⁄₁₆ x 31⁷⁄₁₆ inches. The North Carolina

Museum of Art, Raleigh.

Landscape, Polling, Bavaria, ca. 1878, oil on canvas, 23 x 31 inches. Cincinnati Art Museum, 1915.127.

Heads and Hands, Study, 1879, oil on canvas, 23³⁄₁₆ x 46¹⁄₁₆ inches. Cincinnati Art Museum, 1915.118.

The Blacksmith, ca. 1879, oil on canvas, 27 x 21¹³⁄₁₆ inches. Cincinnati Art Museum, 1915.81.

Man With Ruff, ca. 1875, oil on canvas, 24¾ x 19¼ inches. Mr. and Mrs. David A. McCabe.

Portrait of John W. Alexander, 1879, oil on canvas, 38¹⁄₁₆ x 22¹⁄₁₆ inches. Cincinnati Art Museum, 1908.1216.

Seated Nude, ca. 1879, oil on canvas, 34 x 26½ inches. Collection of Stuart Pivar, New York, at the University of Virginia.

Laughing Boy, ca. 1879, oil on canvas, 22 x 18⅜ inches. Nebraska Art Association, Nelle Cochrane Woods Collection, Courtesy of Sheldon Memorial Art Gallery, University of Nebraska-Lincoln.

Study of Three Heads with Salver and Jar, ca. 1879, oil on canvas, 33½ x 44⅞ inches. Cincinnati Art Museum, 1915.77.

Study for Guard of the Harem, 1879, oil on canvas, 30 x 26 inches. Duveneck Family.

Guard of the Harem, ca. 1880, oil on canvas, 66 x 42¹⁄₁₆ inches. Cincinnati Art Museum, 1915.115.

Portrait of Amy Folsom, 1880, oil on canvas, 36 x 24 inches. From the collection of the Montclair Art Museum, Montclair, New Jersey.

The Venetian Girl, ca. 1880, oil on canvas, 34 x 24¾ inches. The Cleveland Museum of Art; Gift of Mrs. Henry A. Everett for The Dorothy Burnham Everett Memorial Collection.

Portrait of Miss Blood (Woman in a Satin Gown), 1880, oil on canvas, 48 x 28 inches. The Warner Collection of Gulf States Paper Corp., Tuscaloosa, Alabama.

Head of a Girl, ca. 1880, oil on canvas, 16¹⁵⁄₁₆ x 15 inches. Cincinnati Art Museum, 1915.75.

Italian Girl, ca. 1880, oil on panel, 10 x 8 inches. Private Collection.

Study of a Woman's Head, ca. 1880, oil on panel, 13 x 8½ inches. Harvard University Art Museums (Fogg Art Museum). Purchase from the Louise E. Bettens Fund.

A Fellow Artist in Costume, Portrait of Julian Story, ca. 1880, oil on panel, 13½ x 10½ inches. Mr. and Mrs. Dale C. Bullough.

Pool at Polling, Bavaria, ca. 1880, oil on canvas, 15⁷⁄₁₆ x 21⁹⁄₁₆ inches. Cincinnati Art Museum, 1932.83.

Harbor, Chioggia, ca. 1880, oil on canvas, 19½ x 27¾ inches. Addison Gallery of American Art, Phillips Academy, Andover, Massachusetts, (Candace C. Stimson Bequest).

Portrait of Francis Boott, 1881, oil on canvas, 47⁹⁄₁₆ x 31¾ inches. Cincinnati Art Museum, 1969.633.

Scene in Venice, ca. 1881, oil on canvas, 13 x 23¼ inches. Private Collection.

Polling Landscape, 1881, oil on canvas, 16 x 24 inches. Indianapolis Museum of Art; Given in memory of Charles Stayton Drake, (Gift of Mrs. Charles P. Mattingly, Indianapolis).

Boston Common in Winter with the State House, ca. 1881, oil on canvas, 20 x 14 inches. The Daphne Farago Collection.

Portrait of Mary Cabot Wheelwright, 1882, oil on canvas, 50³⁄₁₆ x 33³⁄₁₆ inches. The Brooklyn Museum, Dick S. Ramsay Fund (40.87).

Head of an Old Man, ca. 1883, oil on canvas, 22¹⁄₁₆ x 18 inches. Lent by The Toledo Museum of Art; Gift of Florence Scott Libbey.

Water Carriers, Venice, 1884, oil on canvas, 49⅜ x 73⅛ inches. National Museum of American Art, Smithsonian Institution; Bequest of Rev. F. Ward Denys.

Steamer at Anchor, Twilight, Venice, ca. 1884, oil on canvas, 49 x 66³⁄₁₆ inches. Cincinnati Art Museum, 1915.148.

Reading to Chioggia Fishermen, ca. 1884, oil on canvas, 56 x 87 inches. Cincinnati Art Museum, 1915.123.

Portrait of Josephine Niehaus, ca. 1885, oil on canvas, 47½ x 29¾ inches. Cincinnati Art Museum, 1965.277.

Miss Molly Duveneck, ca. 1885-1890, oil on canvas, 17 x 12⅛ inches. Collection of the Akron Art Museum; Bequest of Edwin C. Shaw.

Portrait Sketch of Elizabeth Boott, ca. 1885, oil on canvas, 17 x 13 inches. Duveneck Family Collection.

Portrait of Elizabeth Boott, ca. 1886, oil on canvas, 17 x 14 inches. Duveneck Family.

Walls of Villa Castellani, ca. 1886, oil on canvas, 24 x 18 inches. Duveneck Family.

Washer Women, Venice, 1885, oil on canvas, 37½ x 45 inches. The Canton Art Institute; Gift of an Anonymous Donor.

Italian Courtyard, 1886, oil on canvas, 22¼ x 33³⁄₁₆ inches. Cincinnati Art Museum, 1915.76.

Italian Girl with Rake, 1886, oil on canvas, 34 x 24¾ inches. Vose Galleries of Boston, Inc.

Florentine Flower Girl, 1887, oil on canvas, 31 x 32 inches. Private Collection.

Head of an Italian Woman, 1887, oil on canvas, 20 x 127 inches. National Academy of Design, New York.

Siesta, 1887, oil on canvas, 34¾ x 64⅞ inches. Queen City Club.

Portrait of Elizabeth Boott Duveneck, 1888, oil on canvas, 65⅛ x 34¾ inches. Cincinnati Art Museum, 1915.78.

Boy Wearing Cloak, 1888, oil on canvas, 20¹¹⁄₁₆ x 17⁹⁄₁₆ inches. Cincinnati Art Museum, 1915.88.

Portrait of Marie D. Page, ca. 1889, oil on canvas, 38 x 25¼ inches. Cincinnati Art Museum, 1915.100.

Photography Credits

Lenders to the Exhibition

Addison Gallery of American Art, Phillips Academy, Andover, Massachusetts
Akron Art Museum
Brooklyn Museum, New York
Mr. and Mrs. Dale C. Bullough
Canton Art Institute, Ohio
Cleveland Museum of Art
Corcoran Gallery of Art, Washington, D.C.
Detroit Institute of Art
Duveneck Family
The Daphne Farago Collection
Fogg Art Museum, Cambridge, Massachusetts
Indianapolis Museum of Art
Mr. and Mrs. David A. McCabe
Metropolitan Museum of Art, New York
Milwaukee Art Museum
Montclair Art Museum, Montclair, New Jersey
Museum of Fine Arts, Boston

National Academy of Design, New York
National Gallery of Art, Washington, D.C.
National Museum of American Art, Washington, D.C.
North Carolina Museum of Art, Raleigh
Pennsylvania Academy of the Fine Arts, Philadelphia
Collection of Stuart Pivar at the University of Virginia, Charlottesville
Private Collections
Queen City Club, Cincinnati
Rosenberger Gallery, Centerport, New York
Sheldon Memorial Art Gallery, Lincoln, Nebraska
Taft Museum, Cincinnati
Toledo Museum of Art, Ohio
Vose Galleries, Boston
Warner Collection of Gulf States Paper Corp., Tuscaloosa, Alabama

Index